Spiral Jetta

Also in the Culture Trails series

Pilgrimage to the End of the World
The Road to Santiago de Compostela
CONRAD RUDOLPH

Spiral Jetta

A Road Trip through the Land Art of
the American West

Erin Hogan

The University of Chicago Press
Chicago and London

ERIN HOGAN is director of public affairs at the
Art Institute of Chicago.

The University of Chicago Press, Chicago 60637
The University of Chicago Press, Ltd., London
© 2008 by The University of Chicago
All rights reserved. Published 2008
Printed in the United States of America

17 16 15 14 13 12 11 10 09 08 1 2 3 4 5

ISBN-13: 978-0-226-34845-2 (cloth)
ISBN-10: 0-226-34845-8 (cloth)

Library of Congress Cataloging-in-Publication Data

Hogan, Erin.
 Spiral Jetta : a road trip through the land art of the
 American West / Erin Hogan.
 p. cm.
 Includes bibliographical references.
 ISBN-13: 978-0-226-34845-2 (cloth : alk. paper)
 ISBN-10: 0-226-34845-8 (cloth : alk. paper)
 1. Earthworks (Art)—West (U.S.)
 2. West (U.S.)—Description and travel.
 3. Hogan, Erin—Travel—West (U.S.) I. Title.
 N6512.5.E34H64 2008
 709.04'0760978—dc22

 2007049900

♾ The paper used in this publication meets the minimum
requirements of the American National Standard for
Information Sciences—Permanence of Paper for Printed
Library Materials, ANSI Z39.48-1992.

For my *prima*, Karyn Lyons

Contents

Thanks to Susan Bielstein, Anthony Burton,
Joel Score, Jill Shimabukuro, Levi Stahl,
Randy Petilos, Todd Tubutis, Ruth Lopez,
and Bonnie and Brian Hogan.

Chapter 1 } Spiral Jetty

In the late 1960s the artist Robert Smithson went looking for red. Scouting possible sites for what would eventually be his signature work, the *Spiral Jetty*, he wanted, he wrote, quoting G. K. Chesterton, "that most joyful and dreadful thing in the physical universe . . . the fiercest note . . . the highest light."

Forty years later, I too wanted something joyful and dreadful, fierce and high, though it didn't have one color, one shape, or one form. I wanted four hundred stainless steel poles, four concrete tubes, two deep gashes in the earth, and a coil of rocks. So I went out in the late summer looking for these and other monuments of American land art. But I was also looking for something like Smithson's red—perhaps more elusive, but just as joyful and dreadful. I wanted to learn to enjoy being alone.

I have lived in Chicago for seventeen years, and by now I have what might be called an "urban sensibility." I have an urban haircut—very short, trimmed every four weeks. I have an urban wardrobe—mostly black and gray suits, accented by black and gray shirts, worn invariably with black high heels (a futile attempt to enhance my five-foot stature). I have urban eyewear—titanium-framed glasses designed by a German. I enjoy the energy and movement of cities, the sense of being part of a larger whole of people and stories and sights and lights. And I take comfort in being surrounded by a constant clamor of voices—of strangers, of friends—and el trains and car horns and music from passing cars and the rhythms of the boys drumming on overturned buckets on the sidewalk.

So my trip through land art* would be an unprecedented assault on my own fear of solitude. As a recovering art historian, I had long been interested in seeing the artworks of the West as they are supposed to be seen. But as someone undergoing a sort of early midlife crisis, I was also interested in testing and challenging myself, breaking out of my nine-to-five routine and trying to find something in myself beyond the ability to answer e-mails, attend meetings, and meet friends for cocktails. This was a fearful undertaking, to be sure, but I had downplayed its solitary aspect by simply refusing to think too much about it beforehand. I couldn't bring myself to face the magnitude of this trip: three weeks on the road, most of it alone, through states I had never seen, without any idea where I would stay or what I would do. Had I put any real thought into the trip—beyond buying a map and picking out a few places I wanted to visit—I never would have been able to go through with it. So instead I willed myself into denial and approached the journey casually.

Even the morning I left was leisurely. I opted out of the "road trip" script I remember from childhood—my parents setting the alarm for an ungodly hour, rousing me and my sister, pushing us sleepily into the already packed car while it was still dark outside. Not this time. On the morning I left for the West, I slept in, had some coffee and breakfast, watched the *Today* show, and threw my bags into my six-year-old city-driving Volkswagen Jetta. And then, at the godly hour of 10:30, I drove away.

My first stop, after what I figured as a two-day drive, would be Smithson's *Spiral Jetty*. The title is literal: the work is a spiral of rocks and dirt approximately fifteen hundred feet long

* Going against all my training in higher education, I'm going to lump everything I wanted to see into one category, which will be variously called "land art," "earthworks," "American monumental minimalism," or some combination of those words.

and fifty feet across, reaching out from the shore of the Great Salt Lake like a big rubber snake. It was built in 1970 at Rozel Point, fifteen miles from Corinne, Utah, the nearest town. For a while the jetty was visible; then the lake overtook it and it languished, or flourished, underwater for decades. Low water levels and a drought brought it back to the surface in 1999. It slowly emerged, but, like a disgusted lover, the lake that had snuggled it marched away, further and further, and now keeps a healthy distance. The jetty, so long licked, covered, and embraced by the lake, now sits alone, arid and rocky, about a half mile from the water.

Smithson echoed local mythology when he claimed to have seen an "immobile cyclone" while scouting the site. Rumor—the origin of which remains unclear—holds that at the bottom of the Great Salt Lake is a giant whirlpool that is linked, via an underground tunnel, to the Pacific Ocean. Looking into the pink water, into "a network of mud cracks supporting the jigsaw puzzle that composes the salt flats," Smithson described such sensations as a "dormant earthquake," a "flickering light that made the entire landscape appear to quake," "a spinning sensation without movement," "an immense roundness," a "gyrating space" (in Cooke and Kelly, 8). He saw currents of energy working at a feverish pace under the gentle surface of the lake. So he hired a contractor, who managed two dump trucks, a tractor, and a front-end loader in relocating sixty-five hundred tons of earth—mostly black rock, salt crystal, and dirt—into a coil that protrudes out into the lake. It took about six days to craft the jetty. It took me two to get there.

I just started driving, pushing through the plain landscape of western Illinois, crossing into Iowa, hurling myself across Nebraska. I stopped only once, for gas, in ten hours. That first day I would drive some 750 miles. The first of those miles revealed a Chicago I hadn't seen before. Though I've lived in the city for many years, I'd never seen the industrial parks that line

the Eisenhower Expressway. I'd never seen the concrete and asphalt give way to the prairie I know Chicago was built on. Sailing on, I passed the world's largest truck stop and the Iowa rest stops, equipped with wireless Internet. The hours melted and my brain settled into an easy state; I had every thought and no thoughts at all. Making little deals with myself to pass the time ("at 3:12 I will have a banana"), I found myself wondering where the time went when I looked at the clock again and discovered it was 5:30. I was driving due west, the sun full in my eyes as it descended in the late August afternoon.

The drive west from Chicago is an easy one. Iowa and Nebraska offer little drama or grandeur. The word that comes to mind is *pleasant*. Pleasant farms, pleasant towns, pleasant fields. Even the animals look pleasant—placid cows, gentle horses, lazy flocks of birds. Later, in Wyoming, I passed livestock farms that stunk so much you could smell them a mile before and a mile after, but in Iowa and Nebraska—except for the slaughterhouses smack in the middle of Omaha—livestock seemed tame and easy, a palatable sort of farming for the uninitiated. There are more fields than animals, and the fields have a regular beauty. Rows of crops flashed in the corner of my eye, rectilinear plantings so uniform that they could have been designed by Donald Judd. Some fields had huge rolls of hay placed at regular intervals, as if a farmer had dropped them at algebraically defined points on a geometric grid. I'd like to know what kind of innate visual sense is at work in farmers who have never heard of minimalist art. Or, conversely, what Judd thought as he rolled past these farms. Judd was born in Excelsior Springs, Missouri, and I like to imagine that his militarily precise works reached back into his childhood and the particular organic geometry of farmlands and fields. Agnes Martin and her careful grids would make an even better comparison here. She was born in Saskatchewan, Canada, a place I've never been. Reliable sources tell me, though, that

it shares some of the characteristics of the American plains, so Martin's sense of space, meticulously gridded and grounded, might thus also be an attempt to recall and refine the flat landscapes of her birth and youth.

I felt lonely as the sun set and my first day of driving came to a close, and I motored on until nine o'clock to postpone the sense that I was stationary and alone at what seemed the lip of civilization. I wound up in North Platte, Nebraska, in the western half of the state.

North Platte is Buffalo Bill Cody's town. Not his hometown or burial place—he just owned some property there. Nevertheless, he is grandly memorialized by "Fort Cody," a two-story structure combining museum, gift shop, and theater, right off the exit from I-80. There someone stages a "Buffalo Bill show" in miniature, as I understand it, with puppets. Surrounding Fort Cody are cannons and other armaments; on the second floor, where one assumes sentries would be posted, are the worst looking dummies I've ever seen—worse even than those at the museum at the Donner Pass Memorial State Park in Truckee, California, which until now were the worst historical mannequins I'd encountered. Limp and scarecrowish, cradling guns in their noodle arms, the Buffalo Bill sentries crumple and drape over the edge of the balcony. Were I Buffalo Bill I would have to have a long, hard talk with my sergeant at arms in Nebraska. Ten-year-olds could easily storm this monument to the fierce frontier scout.

I ate dinner, having survived the whole day on bananas and bottled water, at the bar of the Whisky Creek Saloon, a stone's throw from Fort Cody. I could make this place sound all "western" by describing the smell of smoked meat and the peanut shells that littered the floor, but in truth it felt like a cheap theme restaurant, complete with waitress name tags in the shape of sheriff's stars. The bartender, Amy, had a lot to say, and I was grateful for that, having barely spoken all day.

Amy had big and broken dreams: selling southwestern "artifacts" to Nebraskans, a plan for a rental storage facility stolen out from under her by a greedy developer, a furniture business she was going to start with her husband. We talked about astrology and tarot (she rhymed the word with "carrot") readings. I was deeply impressed by her optimism and entrepreneurship, and I figured she was trustworthy enough to ask where I should stay.

"Try the Howard Johnson's in North Platte. It's on the ones," she told me.

"The ones?" I asked, having seen no numerical street names.

"Yeah, you know, the ones that go in and the ones that go out." She held up her arms in a sort of cheerleader pose, chest high, elbows bent, forearms in front of her, parallel to each other and to the floor. I nodded and pretended I understood. Later I realized that she was talking about the two one-way streets that enter and exit North Platte, which locals refer to as "the ones."

I stayed talking to Amy and a lumber salesman from Colorado until the peanut shells were swept up and the sheriff's-badge name tags came off. I knew it was time to admit that I was a stranger in a strange town, alone out there in the middle of the country. So I went out "on the ones" and checked into the Howard Johnson's. I brought my bags into the room and set to work pretending I wasn't horribly alone. I busied myself looking at a map of the next day's route (which involved nothing more than staying on the same highway), flossing my teeth, talking on the phone, staving off the minute when I would actually have to be quiet, be at rest, in an unfamiliar and lonely motel room far from home. It was the moment I had avoided thinking about, the moment in which my mind would be forced to settle and the enormity of what I was undertaking would be upon me—the most extended period of time I've ever been alone.

I would like to think that I am the sort of person, like Agnes Martin or a desert father, who could live alone in the wilderness indefinitely. I would settle for being the kind of person who can contentedly read a book on a mountaintop. But I recognize that I am not either of those kinds of people. I need noise and companionship and coworkers to protect me from anxiety about my own atomic existence. Combating this need for constant distraction was one of the purposes of this trip. I've traveled pretty widely—South America, Europe, northern Africa—but it has always been with at least one other person. I've never even had particularly long commutes. The most significant period of isolation I'd ever endured was one Christmas break in college when I screwed up my flight home and wound up staying in an empty dorm for two days. By the end of that time I was climbing the walls, convinced I was having a nervous breakdown.

Friends of mine have backpacked solo through Europe. A coworker routinely goes alone to his parents' cabin in northern Minnesota, an isolated spot where cell phones don't work, for two weeks at a time. When I learned this about him, I was as fascinated as if he had told me he was raised by a tribe of bloodsucking pygmies. I grilled him endlessly about the sensation of being that alone. "I start talking to myself after a few days," he told me, "just to hear a voice. But after a week or so, I even forget to put on music. The quiet just gets inside of you and wraps around you at the same time. It's kinda nice." I wanted this trip to be a test of my own devices, to explore whether I had developed at all since those dark December days watching television in an empty dorm lounge, emergency lights glowing red in the hallways.

In my hotel room, I waited nervously for that "kinda nice." Before I left, when I thought about the trip, I had rehearsed, in my head, absorbing conversations with strangers and "characters"; I pictured myself happy, driving and listening to

music with my left arm hanging out my open window as the landscape sped by. I imagined myself thinking deeply about important things, like a new theory of modernism. These hopeful images were my protection against what I came to call the "Howard Johnson moments," when day settled into night, when I was done moving and traveling and seeing and learning and instead had to crawl into an empty bed in the middle of nowhere.

I guzzled some water as I switched off the light and started to choke on it. Struggling to breathe, I had a flash of my corpse lying on the scratchy motel carpet, discovered by a cleaning woman the next morning after checkout time. Still coughing, I angled myself over to the door, ready to open it and throw myself into the open-air hallway so it would be easier—and quicker—for others to discover my body. As I leaned on the doorjamb, I caught my breath and recovered enough to get back into bed.

The next day I entered Wyoming. Nudged up against placid Nebraska, Wyoming is breathtaking. Along the Continental Divide you climb to about eighty-six hundred feet but somehow never feel the ascent. It happens magically, and when you step out of the car at a rest stop, the air feels like fresh, cool water rushing over your body. Wyoming is empty and spacious, with signs that say "No Services Next 28 Miles" and exits that appear to lead nowhere. It's mining and oil refining country, desolate stretches broken up by broken-down trailer parks. All of the action seemed to be on the highway.

Truckers honked and waved at me as I pressed on through the vast rolling landscape. "Truckers will always honk at a woman driving alone," warned my friend Jenny before I left on my journey. Jenny used to drive to her parents' house in Missouri from Chicago in a car that had no air conditioning. During the summer, in deference to the heat, she would wear the shortest shorts she owned and a bikini top for the ten-hour

drive. I suspected that that was why truckers honked at her. I was more modestly dressed, but apparently it doesn't matter; truckers dig a little girl in a black Jetta moving at ninety miles an hour. Cows lounged around and flicked their tails. There were oil refineries but little else—miles and miles of hills and bluffs and dunes and grass with few trees. O Pioneer! Those poor pioneers, going so long without shade. Even the campsite signs in Wyoming promise SHADE first, then SHOWERS WATER.

Coming into Utah, the rolling hills give way to cliffs and rock formations, and the road winds and swirls. In Wyoming, the long, seemingly flat straightaways work as a speed tunnel. Once you cross the state line, though, you have to dial back. Things slow down and get twisty; the road runs through valleys with brooks and tidy horse farms. The next thing you know, you're looking at ski slopes carved into the mountains, ranch houses giving way to expensive condos the closer you get to the base of the hills.

Salt Lake City was to be my base camp for the trip out to *Spiral Jetty*. A seemingly intelligible grid built around the Mormon center, it wasn't as easy to navigate as I assumed it would be. I didn't even know which exit to take for downtown, so I chose one randomly as I sensed I was passing the city. It dumped me onto State Street, on what has got to be the wrong side of the tracks, something I—perhaps naively—didn't realize was possible in a Mormon town. Pawn shops, shuttered liquor stores, check-cashing establishments, and tattoo parlors ("a new needle every time," boasted one) lined both sides of the street. I passed a few motels advertising twenty-seven-dollar rooms and kept them in my head while I looked for an Internet café to do some research on lodging, because, trying to force spontaneity on myself, I had made the rule that I couldn't plan anything in advance.

Thinking that the university neighborhood was a likely

spot for such a place, I took State Street all the way up to Temple Street, then headed east. Only later, when I looked at a map, did I realize that I had been directly in front of the Mormon Temple. I had imagined it as a shining, complex edifice—surrounded by some sort of aura or halo—at the base of a mighty peak. Instead, folded in among bland office buildings and lacking an aura or halo, it was so unremarkable I had passed by without noticing it. The glowing white temple is in fact small and somewhat gray—a foreshadowing of the gap between imagination and reality that I would repeatedly confront on this trip.

Across the street from the public library I found a struggling Internet café where I could check my e-mail, pay some bills, and search for a place to stay. Striking out on hostels (which I wouldn't have stayed in anyway, once I saw the pictures of thick wood bunk beds, dirty blankets, and a sleep odor that I swear was visible on screen), I got back in the car to troll for hotels. I drove back to one of the twenty-seven-dollar places, but even the desk clerk who showed me the room admitted he didn't think I should stay there. There were vacant rooms at the Howard Johnson's on the west side of town, which online seemed to be the cheapest place. But I didn't like the snippy seventeen-year-old desk clerk, so, cutting off my nose to spite my face, I refused to stay there. At the Travelodge, I fell into a conversation with an older hippie type who, missing a row of teeth, resembled an apple doll. He couldn't really recommend the Travelodge, but then he didn't think the cheap hotels on State were that bad. "Pretty clean, I think," was his assessment.

"It was on State Street where I had my first car wreck. I was sixteen, in my dad's car, and you know how it is then, you've just got your license and there are like a million other kids in the car. And the next thing you know I slammed into somebody. All the other kids except one left me to deal with it.

Nobody got hurt, and I only bent the other guy's fender, but that's all I can think of when you say 'State Street' to me."

I said thanks and left.

My next stop was the Motel 6. I pulled up to find a man with ramrod posture in the parking lot in full army fatigues, pants neatly tucked into his black boots. He stared at me as I approached the motel office, then told me that my haircut was very pretty. I got a room there for forty dollars. Not bad, but more than I could sustain for the next three weeks. I asked the clerk about the army fatigue guy. He stays there a lot, apparently, and might even kind of live there, though he disappears for long stretches at a time and then comes back with some story about being hospitalized for food poisoning. "He'll tell you his life story if you give him any time," the clerk told me. "But he's harmless. If you're worried I can have a security guard escort you to your room." He nodded in the direction of a portly mustached man wearing a dark windbreaker who was watching TV in the other corner of the lobby. I declined but took a circuitous route to my room anyway. When I left the motel to go to a nearby sports bar for dinner, Colonel Flagg was talking to some biker guy on a motel walkway; when I returned he was sitting at the table in his room—the curtain and door wide open—smoking a cigarette, as if waiting for a visitor.

The sports bar was generic. After two very ungenerous vodka tonics ("Kettle One," according to the menu, the shot regulated by a nozzle and cord that fit over the spout of the bottle), a BLT, and a brief conversation with a car rental industry consultant about baseball, priceline.com, and the first Gulf war, I returned to my room. I reviewed the *Spiral Jetty* directions and literature, eager for my first in-the-flesh encounter with land art. I was excited. Having conquered the dread of my first motel night in North Platte, I felt confident about my mission and abilities.

The next morning, despite detailed directions, I made my first navigational error. My instructions, passed on via an e-mail forwarded a hundred times, said to go north on I-80. Though I had pored over the directions—then traveled due west on I-80 for two solid days—it hadn't occurred to me until now that I *couldn't* go "north on 80." How could something so obvious have escaped my careful and repeated study of the directions? All those existential thoughts about solitude had clouded my awareness of the simple geometry of west and north. I realized my mistake after one exit and headed over to I-15 instead. *Spiral Jetty* is about an hour's freeway drive, then a half hour's rural-highway drive, then an hour's bone-jarring-road drive from Salt Lake City. It is accessible through the Golden Spike National Historic Site, the place where the Union Pacific joined the Central Pacific railroad to complete the first rail link between the coasts.

It is a beautiful drive the whole way, with mountains on your right as you head north. Once you exit I-15, you wind past the town of Corinne and then into Thiokol country—a name familiar to me as the employer of managers who turned a blind eye to the warnings of engineers about the cold and brittle O-rings that brought NASA's *Challenger* down in 1986. Just before the bulk of the Thiokol complex you bear left onto a smaller road that eventually takes you to Golden Spike. In the middle of nowhere, or at least what I took to be nowhere at the time, there's a railroad track, and I had to stop for a bright and shiny toylike two-car train pulled by a steam locomotive, obviously some demo for visitors to the site. I don't know how far the train runs, but I suspect it's not more than a few hundred yards. The trainmen gave me a jaunty wave as I waited for them to pass.

Though Golden Spike is the gateway to *Spiral Jetty*, the National Park Service doesn't administer the work nor even monitor it closely. The jetty was acquired from Smithson's

estate in 1999 by the Dia Art Foundation, which plays such a role in most of the sites I was visiting that it could almost be considered the architect of my trip. The Dia Foundation was started in 1974 by a prescient German and an American heiress, Heiner Friedrich and Philippa de Menil, and, despite subsequent permutations and tribulations, it remains the signal institution in the United States committed to highly site-specific (and some might say, difficult) works. It supported—by buying land, commissioning works, paying stipends to artists, providing materials—much of the monumental art of the 1970s and 1980s, which, because of its size or ephemerality, couldn't find expression in the standard gallery-museum circuit. Dia is now the custodian of *Spiral Jetty* and many of my other destinations, including *Roden Crater*, the *Lightning Field*, and, to a lesser extent, the town of Marfa, Texas. A few years ago the foundation opened Dia:Beacon, a breathtaking museum in the Hudson River Valley that is a contemporary art sanctuary, with every inch cultivated and plotted for a maximally aesthetic experience.

Some complain that the Dia "mafia" supports a small and privileged group of artists and is not attentive enough to different currents of artistic inquiry—like personal identity, social systems, or even history. It is true that Dia puts its money behind a very specific and limited type of work. It is also true that Dia puts its money behind the work I find most compelling—ambitious, beautiful, rigorous, geometric, engaged with questions of form rather than personality, aiming at the eternal without irony.

Knowing, then, that the Golden Spike park rangers could do little for me in terms of the *Spiral Jetty*, I checked in at the visitors center anyhow, mostly so that someone would be able to trace my last steps should any disaster befall me. I was relieved to learn that the park had the same directions that I did, and a ranger said that the park had even put up signs

("if they haven't been stolen") to direct visitors to the work. She said it would take about forty-five minutes to get there because of the condition of the road. I asked what would happen if I got stuck; she said I'd be out of luck, because there's no cell phone coverage out there. She must have seen a look of alarm cross my face because she quickly added that at least one other person, a woman, had also stopped for directions and was already there.

What followed was a drive on something that could be called a road only because it had boundaries on the left and the right. As soon as I left the visitors center parking lot, the road became so rutted that water was bouncing out of an open bottle in my cup holder. I couldn't go more than twenty miles an hour without the sense that I was doing real damage to the car. At points the road smoothed out a bit and I could get up to about forty miles an hour, but only briefly and only after desensitizing myself to the sound of rocks constantly pinging up into the body of the car. It felt rough and dirty. Learning to drive in the suburbs of Honolulu, as I had,

then being confined more or less to the civilized purviews of New England and engineered highways of Chicago, I'd never known the sensation of screaming and bouncing and whooping my way down a dirt road in a pickup truck as people do in *Urban Cowboy*, *Footloose*, and John Cougar Mellencamp videos. In fact, I think this was the first time I'd ever left a cloud of dust behind me.

I had been on this road for maybe fifteen minutes, gritting my teeth the entire way, when a Subaru blew by me, making me feel like an eighty-year-old driver, timid, hapless, and scared. I watched as the car tore up the road in front of me. Its dust cloud seemed endless, rolling over the landscape and filling me with trepidation about how far I still had to go.

There were four or five signs pointing toward the jetty, which was a good thing because my directions, which were actually quite thorough, included steps like the following:

Drive 1.3 miles south. Here you should see a corral on the west side of the road. Here, too, the road again forks. One continues south along the west side of the Promontory Mountains. This road leads to a locked gate. The other fork goes southwest toward the bottom of the valley and Rozel Point. Turn right onto the southwest fork, just north of the corral. This is also a Box Elder County Class D road.

And

Continue 2.3 miles south-southwest to a combination fence, cattle guard #4, iron-pipe gate—and a sign declaring the property behind the fence to be that of the "Rafter S Ranch." Here too is a "No Trespassing" sign.

What is a Box Elder County Class D road? How could that detail possibly be helpful when sitting at a fork confronting

three identical gravel roads? The "combination fence, cattle guard #4, iron-pipe gate" sounds like text you would read on a contemporary art museum's label, that strange combination of informative yet useless detail. These directions only served to confuse me, so I continued to thank God for the signs. Without them, I would just have sat in my overheating car, puzzling over which direction was south, helped little by the noon sun directly overhead. I regretted not bringing a compass. I also regretted never having learned to read one.

I continued poking along, wincing with every rut and bump. As the road wound its way between two low ranges, it worsened. Ruts turned into chasms, gravel turned into real rocks. Impelled by some curiously human instinct, I started to speed up, hoping that the faster I went the faster it would be over. I recognize, of course, that this was precisely the wrong thing to do, but just as I drive faster when I'm running out of gas, I couldn't help but inch the car up to thirty miles an hour, literally bouncing in my seat, driving my little Jetta as if it were an off-road vehicle in an extreme road rally, furiously turning the wheel, driving by intuition rather than reason. There were so many pitfalls to avoid—huge potholes, large pointed rocks everywhere underneath me—that to reason my way through them would have been impossible, or at least too time consuming. Instead I gripped the wheel, stopped thinking about all the potential disasters and imagining the hiss of a shredded fuel pump, and prayed that the woman out there ahead of me was a kindly soul who would pick up my parched carcass on her way out. The long dust trail of the Subaru had vanished into the horizon, which meant that the road went far beyond what I could see.

Michael Kimmelman, in his book *The Accidental Masterpiece*, describes the journey: "To drive from the [Golden Spike] monument to the jetty in summertime is a spectacularly beautiful ride through an empty valley rimmed by mountains,

with rushes of cranes flying overhead and fields of black-eyed Susans rising into the rocky slopes, the valley spilling suddenly down to the lake" (182). Kimmelman must not have been in the driver's seat to be able to appreciate this, or perhaps he was driving a rental car and not worried about mortally wounding the most expensive purchase he'd ever made, sixteen hundred miles from his front door. I was in such a state of anxiety that the landscape escaped my notice. I could feel the heat of the day and, when idling and catching my breath, hear the buzz of the insects. But I was fixated on the road, the rocks, the ruts. Later, looking at the pictures I had taken, I could see that the ride *was* spectacularly beautiful—low-rise ranges and hills and bluffs, the Great Salt Lake emerging and receding with every turn. But that was in retrospect. At the time, I was only aware of the car, the hot air, the relentless sun. I pressed on, wincing and moaning and saying "ow" aloud for another half hour.

Finally I came to this juncture:

At this gate the Class D road designation ends. If you choose to continue south for another 2.3 miles, and around the east side of Rozel Point, you should see in the Lake a jetty (not the Spiral Jetty) left by oil drilling exploration in the 1920s through the 1980s. As you approach the Lake, you should see an abandoned, pink and white trailer (mostly white), an old amphibious landing craft, an old Dodge truck . . .

The old Dodge truck is less than half a mile from the jetty, and here I made a mistake, taking the left side of the fork rather than the right. Who could blame me? The directions said: "As you drive slowly past the trailer, turn immediately from the southwest to the west (right), passing on the south side of the Dodge and onto a two-track trail that contours above the oil-drilling debris below." Instead of going from the southwest

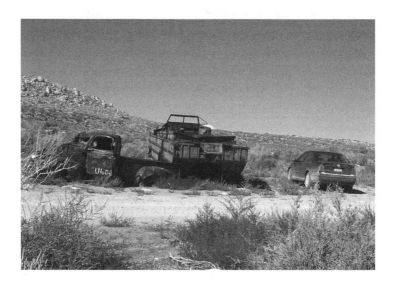

to the west, I guess I went from the southwest to the south, where I immediately ran into two guys in an equally inappropriate sedan with Massachusetts license plates. They told me to turn around, but I just backed up, parking my car next to the Dodge truck and amphibious vehicle, because the directions warned that the road grew even worse beyond this point.

I put two bottles of water, my tape recorder, cameras, and Balance Bars into a bag and set off on foot. The Balance Bars had already melted into tumorous masses. After two minutes—so much for my trek on foot—the *Spiral Jetty* appeared on the left. My first impressions? Much smaller than I had expected, and much whiter. A long way from the water, barely rising from the salty silty surface of the lake bed.

With my first earthwork now in view, I confronted a major discrepancy between what I had imagined—aided by images—and what the work actually was. The "real" size of the jetty bore no relation to my mental picture. I vividly remember the photograph on the cover of my very first art history book,

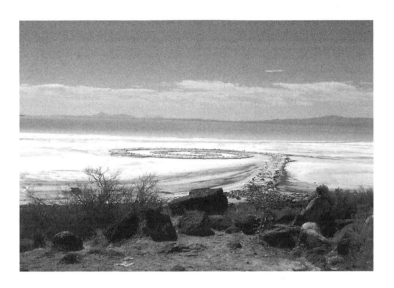

Artforms by Duane Preble. It was the first image of *Spiral Jetty* I had ever seen. The book is now in its seventh edition and long ago changed its cover, but on my copy, the jetty seemed immense, like a coil that could stretch from California halfway to Hawaii. That photograph is like most other representations of *Spiral Jetty* in that it is aerial and unpopulated. Without human figures to put it in perspective, one assumes that it's monumental, on the same vast scale as the surrounding landscape. In actuality it's incredibly intimate, dare I say, even tiny. You can walk its spine in just a few minutes; three or four giant steps can cover the ground between the loops.

There were several people at the jetty when I arrived: the two architects whose car I almost hit, who were in the process of moving from Boston to San Francisco; two recently graduated artists (Lily and Michael) from Los Angeles, who apologized for blowing by me in the Subaru; and Heather, whom I at first took to be some sort of older hippie ecofeminist because she was pacing the jetty alone, in a pensive way. In fact she was an older hippie ecofeminist landscape archi-

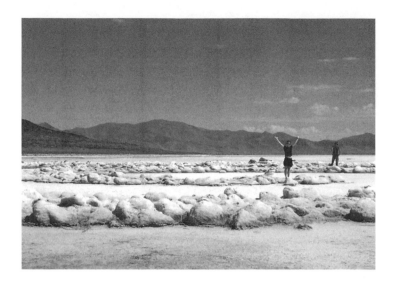

tect, also from Los Angeles, traveling with her boyfriend, Bill. We quickly formed a tight group, sipping water and chatting about the experience. I wondered if we all should be more solitary, but that's not really possible in such a small space. You couldn't walk the jetty without running into someone; you couldn't stand for a moment of quietude without hearing Lily tell Michael, "Look at this."

I walked into the spiral and back out of it. I lay down in the center of it. I crisscrossed its rings. I crouched down and tasted the salt. I looked around, still overwhelmed by the work's nonmonumentality. I tried to experience it physically, without processing it through any art-historical filter. But I couldn't. I couldn't separate my encounter with *Spiral Jetty* from the reading and thinking I had done about art of this era, by now deeply entrenched in my reptile brain. Trying to consider this object in isolation, to bypass art history, was like trying to knock an irritating song out of my head. I only managed to turn up the volume. It was with this force that the views of critics and historians crowded into my consciousness.

Like anything good and complex, *Spiral Jetty* can be thought of in many different ways. As lame as it sounds, those "ways" came down to two for me: space and time. Not small topics, I realize. But *Spiral Jetty* beautifully and subtly distills its experience into those fundamental categories.

When you first see the work and begin your short, sweaty trek toward it, you are forced to consider it spatially. On the drive and on the approach, coming up on the little rise before it, the sense of space is overwhelming. The dry bed of the Great Salt Lake stretches out in front of you, then turns hazily into water and melts into the horizon, where it collides with the vast sky. The mountains surround you, the light and heat envelop you. Being at *Spiral Jetty* engendered in me a sense of articulated space, one that wasn't alienating because it was marked by mountains, edges, colors, which together staved off the disorientation I associate with open, ungridded space, like being on a sailboat at sea. All the elements of the landscape were so distinct, like Ellsworth Kelly's planes of color, that they took on an unlimited sense. Sky meets water meets salt meets land meets mountain. The space is elemental and understandable, only a little overwhelming, and deeply inspiring.

One of the markers of this space is of course Smithson's work itself. It orients you to your minimal place. Expecting it to be grand and finding it is not gives you a sense of human scale in a very unlikely place.

The question of scale and space in *Spiral Jetty* brings to mind the work of Michael Fried, critic, historian, poet. A versatile and creative thinker, Fried has covered centuries of art making, including the long-term project of tracing the roots of American minimalist art back to French painting of the eighteenth century. Yes, you heard me. The eighteenth century. His work on the 1960s has been so influential that even the critics who write about land art for the more-or-less general reader, such as Kimmelman in the *New York Times* and

Calvin Tomkins in the *New Yorker*, can't get through any sort of essay on this work without engaging Fried's ideas. And neither can I.

Written just a few years before the creation of *Spiral Jetty*, Fried's 1967 essay on minimalism, "Art and Objecthood," is still considered to be among the most incisive works of American art criticism of the twentieth century. Like the unparalleled literary criticism of James Wood, "Art and Objecthood" not only described and evaluated then-contemporary art but also placed it within a broader philosophical framework. I have been chewing on this essay for years, and in what follows I'm sure I won't be fair to it. I'll just use it to outline some general themes.

Briefly put, Fried's contempt for minimalism, or what he terms "literalist" art, is based on a definition provided by the artist Robert Morris, predicated on physical presence and a viewer to discern that presence: "The experience of literalist art is of an object in a *situation*—one that, virtually by definition, *includes the beholder*" (153; Fried's italics). The open acknowledgment of a beholder means that such a work, in concept and execution, is not so much art as theater. A literalist or minimalist work *needs* a viewer and isn't an artwork on its own terms. Not only must someone hear the tree fall in the forest; the tree has to wait for someone to get there even to be a tree.

Hinged on the viewer's presence, then, literalist work is diminished and fraudulent, according to Fried. *Real* art (a term he would never use, of course) exists in and of itself; it doesn't need to be staged and then completed by a beholder. A Picasso in the middle of the desert is a work of art; it doesn't need to be seen to be activated *as art*. However, a Robert Morris or a Donald Judd in the desert, which we'll visit later, is merely an object, waiting in the sun for someone to apprehend and complete it. Art is keyed to itself, by virtue of features like

size, material, duration, and internal relationships; objects are keyed to a viewer by the apprehension of them within their specific situation.

Is *Spiral Jetty* a Picasso in the desert? Fried wouldn't think so. For him, land art would be the pinnacle of objecthood. I understand the argument that Judd's boxes, sitting on the floor of a gallery, are in a viewer's space, even in a viewer's way. And if Judd played with this dynamic of objecthood in a gallery, land art would be, I was thinking, its supreme manifestation. Land art takes being *in the way* to an extreme, doesn't it? Born of ripping and shredding the landscape, or relocating sixty-five hundred tons of earth, land art makes itself even more inescapable. It is its own stage, forcing you into a situation defined by itself. As I was to discover, you could totter off the edge of a chasm dug into a mesa; you could walk on landfill out into the Great Salt Lake. "You cannot avoid me," land art and its makers say. "I am here in the way. You can't drive around me. You can't cross over me. You *will* pay attention."

So I thought, in my understanding of land art and its relationship to theories of minimalism, most notably Fried's. But being out in and on *Spiral Jetty* derails that thought. Imagining that this meager pile of rocks, against the broad lakescape of Utah, was forcing itself on me as a viewer didn't quite ring true. How could a work be described as intrusive in Fried's sense if one had to travel so far, so uncomfortably, and with such determination to see it? And how could the "objectness" of *Spiral Jetty* survive when for decades it was underwater, not even discernible to viewers and visitors? How could an absent object be so forceful and demanding?

Standing in the sun, with the white and pink salt reflecting up on my face, I found that Smithson wasn't insisting, in Fried's sense, on a viewer. My tenuous connection of objectness and land art was fatally flawed from the start; even my conception of land art and monumentality wasn't holding up.

Land art was hardly minimalism writ large and in the hand of the natural. Too far away, too difficult to find, too elusive, too submerged. What other claims could I test out here?

I was trying to engage Steve and Chris and Lily and Michael in these questions—"Hey, guys, do you think *Spiral Jetty* needs us?"—but they were more interested in talking about time, a concept Fried also cracks on. "The literalist preoccupation with time—more precisely, with the *duration of the experience*—is, I suggest, paradigmatically theatrical, as though theater confronts the beholder, and thereby isolates him, with the endlessness not just of objecthood but of *time*" (Fried, 166–67). The viewer's consciousness of time is problematic for Fried because, for him, art that isn't theatrical projects a sense of timelessness: "*at every moment the work itself is wholly manifest*" (167; Fried's italics). He writes of the experience of viewing nonliteralist work as a kind of "*instantaneousness*" (again, his italics), a "perpetual present" in which the work itself doesn't unfold or reveal itself but is always there, and true.

There can be no doubt that *Spiral Jetty* reveals itself through time, another black mark in Fried's book. Most people recommend staying out there from dawn until dusk because the play of light across the spiral is most certainly built into the work. But *Spiral Jetty* also engages with a sense of time far deeper than the time Fried is talking about, which is essentially the time it takes to look at a work of art. *Spiral Jetty* is in many ways *about* time, another direct rebuke to Fried's arguments. And it was this dimension of time that my fellow pilgrims were most excited about.

"I'm thinking more about temporality," Chris offered after we had talked about the work's sense of intimacy. "I think that's what I really like about this piece. We were just in Yellowstone, and one of the things that struck us as magical about Yellowstone is that it hits this real sweet spot between the lifespan of a dragonfly and the movement of tectonic plates.

. . . *Spiral Jetty* is in that spot too. We were thinking about when it was just made, when the water was up around it, and what happened when the water disappeared. Now it's salt encrusted. There must have been this beautiful moment when the bacteria had collected against it and really heightened it, and now it actually has this feeling of a ruin or something."

Time was also on Lily's mind. A young woman about to embark on an MFA program, Lily was on her own pilgrimage with her boyfriend, Michael—Michael of the dark jeans with four-inch cuffs and wingtip shoes with no socks and a wife beater and battered fedora and nicotine-gouged teeth, Michael of the rough appeal and soft voice, so young and so L.A. "I'm doing sculpture right now," Lily told me as Michael wandered around taking pictures, "but I'm really interested in natural processes like rust and weathering, and I kind of like to use as a starting point for my work things that nature has already provided or manmade stuff. I scavenge stuff rather than starting from scratch. I like to be given something and work with it from there. This is really cool now to be here thirty years later and see that nature has really taken over.

"It's kind of inspiring," she continued. "A lot of the work that I do feels forced, like I'm forcing nature to work on it. I create rust with sodium dioxide. I create fake weather processes. So to see something that's actually been left out . . . it feels kind of honest and not forced."

Maybe it's the salt that keeps *Spiral Jetty* honest. The work is now almost entirely white. Salt has latched onto every available surface, blanketing it, making it into a *croûte en sel*. It comes across as pink in all the recent pictures I had seen, and perhaps in a certain light it is. The surrounding landscape is certainly tinged with pink—the result of the interaction of algae and bacteria—and out in the water, several hundred yards away, there's a swath of pink like one of the gradations of blue seen in the tropical seas, just a pink ribbon floating out there

close to the water's edge. But the color one feels overwhelmingly is *white*: bone white, bleached white, blinding white. The salt is a "bristling exoskeleton," as art historian Jennifer Roberts described it. "It crunches satisfyingly beneath the hiking boots, mingles (depending on the ambient temperature) with salts from the traveler's own sweat, and sets the jetty into a stunning color contrast with the blood-red water of the lake." More than all of this, though, Roberts recognizes the extent to which the coating of salt defines the sense of time and thus the *Spiral Jetty*:

> The salt cannot, in any traditional sense, be considered part of Smithson's work. It was not originally immanent to the jetty's physical form . . . but only later formed a gentle crust or scale skirting along the spiral's surfaces. It functions as an appendix, a light-footed natural afterthought, to Smithson's own heavy production. Indeed, the salt is the only physical attribute of the jetty that Smithson and his work crew did not manipulate directly. The salt is not quite the jetty but rather a species of patina (arguably the most spectacular example of patina in the history of art). . . . It serves as a material index of the passage of time. (Roberts, B19)

Roberts admits that Smithson, with his "abiding interest in geology and crystallography, clearly anticipated the effect that the natural deposition of salt crystals would have on the work as a whole. . . . Smithson treated salt as a motivating factor for the entire project . . . He insisted that salt crystals be listed along with rock, earth, and water as one of 'Spiral Jetty''s primary media" (ibid.). So, while not quite the happy accident of the cracked glass of Duchamp's *Bride Stripped Bare*, the salt of *Spiral Jetty* was planned and at the same time not planned, expected and anticipated without being, as Lily described her efforts, "forced." The salt simply accrued.

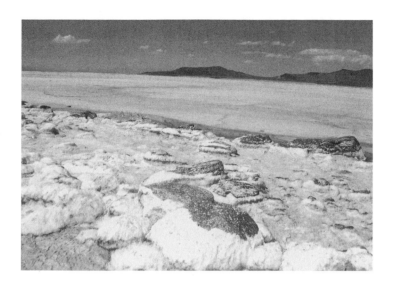

Salt, as Roberts points out, worked for Smithson as an analogue for time. Smithson himself referred to the "crystalline structure of time"—"and this spiraling growth pattern became an essential part of his understanding of that structure." So while one might assume that the salt, which more than any other element gives the work its sense of time, was the most variable aspect of *Spiral Jetty*, it was seminal to it. No bulldozers and backhoes could have dictated the shifting water levels over the decades and the way the salt would form and layer upon itself; no amount of calculation could have predicted the color of the salt or the rate at which it would overtake the surfaces of the moved earth. It was as if Smithson had carefully set up a Petri dish and then allowed its contents, beneath the surface of the lake, to grow unchecked and unscrutinized, and then to emerge, as if from a chrysalis, in a different form.

Smithson had planned on erosion and change, he had planned on the slow shifting of the work over time. In relation to another work, he told Kenneth Baker, "Time is always there gnawing at us and corroding all our best intentions and

all our most beautiful thoughts about where we think we're at. It's always there, like a plague creeping in, but occasionally we try to touch on some timeless moment and I suppose that's what art's about to a degree, lifting oneself out of that continuum" (in Cooke and Kelly, 155). By working at the level of personal duration—how the sun moves, what the water looks like at a given moment—*Spiral Jetty* forces us into the present. But seeing the salt and the erosion, we are left to confront this sense of time that is greater than we are. We are lifted out of our continuum. Fried believes modernist art lifts us out by giving us a perpetual present; Smithson believed his work lifts us out by suggesting the *longue durée*.

There is a certain extent to which the artists behind land art surrender control of their objects to natural processes. At one end of the spectrum is Walter De Maria, who left specific instructions for *Lightning Field* that involve replacing damaged poles to preserve the work's regularity. *Lightning Field* doesn't age as *Spiral Jetty* does. But for *Spiral Jetty*—and Michael Heizer's *Double Negative*—there are open questions about the level of intervention the work requires. On the one hand are those who don't want to see these earthworks erode and disappear. To this end, in 2004, the Dia Foundation was considering trucking more rocks to Rozel Point and building the jetty back up. Others feel that the changes wrought by time are essential to the works, and that they should be left to nature's devices. Smithson himself never gave any definitive answer to the question. While he built natural processes into his conception of the work, he also at points seemed to suggest that he wanted *Spiral Jetty* preserved. As of this writing, no reconstruction has been initiated.

Fried's "Art and Objecthood" tackled the big ideas: space and time. So did Smithson. It seems they were speaking the same language but in a completely different dialect. *Spiral Jetty* complicates Fried's criteria, rendering them more flexible:

it questions one of Fried's tests and fails the other. *Spiral Jetty* does indeed set up a very specific situation for a beholder, though the fact that the work wasn't even visible for a period of time renders that aspect of Fried's argument problematic. Size was important to Fried, but scale—and the difference between size and scale—were more important to Smithson. And while Fried writes of the "perpetual present" of art and the durational quality of "objecthood," Smithson gave us a work that unfolds in the time it takes to view it and changes radically over the course of its existence.

And yet . . . *Spiral Jetty* might also be that Picasso in the desert. It might, productively, be both art *and* object. I had the sense there, at the edge of the Great Salt Lake, that the work really was complete within itself, that it didn't need me, that all my thoughts about space and time and Michael Fried and "objecthood" were beside the point. The spiral is subtle and strong; it is elemental and clean and, yes, perfect. Even the main contractor who built it, Bob Phillips, recognized this fact. When the work was originally completed, Smithson congratulated everyone for their fine effort and "everybody just went home" (in Cooke and Kelly, 192–94). A week later, however, Phillips received an "anxious" phone call from the artist. "It's not right. It's just not right," Smithson said then. "It's all wrong. We need to fix it." Three more days were required for this "adjustment." "But, when it was done," Phillips writes, "I went out to look at it, and it was absolutely astonishing—the feeling I got looking at it that second time, compared to what I got the first time. It went from 'That's a good-looking dike I built' to 'My word, that's sensational, the way that looks.' It was just—it was beautiful" (in Cooke and Kelly, 196).*

* I recognize this "completion" stereotype for what it is and feel the need to mention here an episode of *Malcolm in the Middle* in which Hal, the father, quits his job to fulfill a lifelong dream of being a painter. He starts working on his magnum opus in the garage, driving his family crazy. He brings them in for the unveiling

Smithson's essay on *Spiral Jetty* reads like a stoner's manifesto, all over the map and deeply profound: he hits Brancusi's sketch of James Joyce as a "spiral ear"; he talks about lattices, a sense of scale that "resonates in the eye and the ear at the same time," a "reinforcement and prolongation of spirals that reverberates up and down space and time." Taking a breath, he concludes, "So it is that one ceases to consider art in terms of an 'object'" (in Cooke and Kelly, 9).

And I finally knew what he meant. There *is* something in *Spiral Jetty* that gives it the internal coherence, the completeness, the self-containment and instantaneity, that makes art. It is a physical quality of a supremely constructed entity, with complex internal relationships that harmonize into a glorious whole. So while it is a rebuke to Fried, it also works as a quiet assent, possessing that indefinable, ineffable power that Fried ascribes to the truly singular masterpiece.

After I had been at *Spiral Jetty* for about an hour or so, the architects left. Shortly thereafter, Lily and Michael left. As if I had become, by virtue of my microcassette recorder, the organizer of the visit, they all checked in with me before climbing back into their cars. The architects took my phone number and told me they'd give me a call if they stayed in Salt Lake City for the night. Lily and Michael asked for my e-mail address, so they could send me the pictures Michael had taken, and asked if I wanted to drive out with them, caravanning to

of his paint-soaked mess, and the family is underwhelmed. Wife Lois knows Hal is not satisfied and goads him into admitting that point. In a rage, he says, "You want me to finish this? Like this . . . ?" He throws some paint on the surface. "And like this . . . ?" More paint. And then the work falls into some perfect form, and the disgruntled group in the garage looks at the wall of paint and says, "Oh, wow . . . oh, wow" and "That's beautiful," with beatific looks on their faces. Hal, and his family, realize it is a masterpiece. And then, because this is a sitcom, the whole slab of paint slides off its surface and the work is gone forever. And Hal goes back to his job.

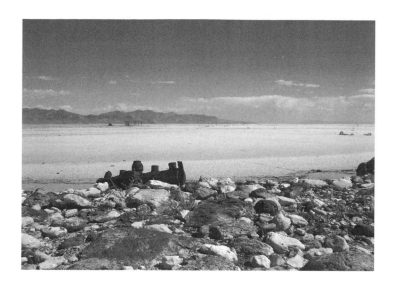

ensure that I was OK. I realized then that my anxiety about
the drive had been as palpable out there at *Spiral Jetty* as the
dazzling sun. Having made it that far in a passenger car, I as-
sured them I would be fine. Heather and Bill were the only
ones remaining at the end of the afternoon. They were plan-
ning to hike up to a ridge to take pictures of the jetty as the
sun set. I somehow read in their tone that "hiking and tak-
ing pictures" was a euphemism for "having sex in nature," so
I hustled on out of there while they called after me, "Don't
worry! We have your back!"

On my way back to my car, before starting the long haul
back to Golden Spike, I walked the oil jetty that sits about
two hundred yards from Smithson's masterwork. Sulfurous
and sullen, this exposed section of the lake bed is perforated
by oil pipes that poke out of the gelatinous brine amid stag-
nant green pools and emits a truly foul odor. An ancient truck
axle erupts from the ground, and rusted pipes litter the land-
scape. Corrosion, decay, extinction—is it any accident that
these two sites sit side by side? Rust and salt, erosion and quiet

disaster, are as much hallmarks of the West as big skies and unpopulated vistas.

I bumped and jarred and panicked on the drive back. For the first time that day I worried more about getting lost than ruining my car; on the return from the jetty there are more forks and alternates visible than on the trip in. A wrong turn meant Heather and Bill wouldn't find me. I envisioned a punctured fuel tank, a night spent eating recongealed Balance Bars and drinking warm water.* I tried to think of the longest run I had done along the lakefront bike path in Chicago in the past six months, wondering if it would be enough to get me out of there and knowing that it couldn't possibly be. Yet, listening to deep house music as the sun set in the middle of the desert, I felt exhilarated.

On the drive out I passed a few more pilgrims heading toward the jetty. A fortyish man was walking down the road about two miles from the jetty; about three hundred yards behind him was a slightly older woman carrying a water bottle and wearing a tennis visor. They were together, but he was obviously the scout party. Both asked me how much further it was and whether it was worth it. I didn't know what to say to the latter question and simply replied, "It's probably something you're only going to see once in your life." I didn't want to tell them that it was probably smaller than they thought it would be, that it pokes up out of the lake bed like an orderly rash, that Heather and Bill were probably running naked through the scrub brush.

I foolishly had worn my bathing suit, bearing in mind an article from 2003 in the *New York Times* that had described people swimming around the *Spiral Jetty*, and as I was breathing a sigh of relief and passing the Golden Spike park, I found

* Smithson himself suffered a "gashed gas tank" when scouting the Great Salt Lake for his work.

myself disappointed that I hadn't had the opportunity. Part of my disappointment stemmed from wanting to be close in every way to the work—in the same way that I felt a shiver when, in a museum conservation lab, I surreptitiously ran my fingers over the surface of a painting by a very famous artist—but most of it was because I have a real salt fetish. I collect salt; I revere salt; I have jewelry made of salt; I had a salt lick in my dining room, which someone had given to me as a joke; I used to furtively eat rock salt from the water softener in the garage when I was a kid; I have salt from the Himalayas and Hawaii and England and China. I've never been to the Dead Sea, and I had read that the Great Salt Lake was as close as someone traveling North America was going to get, so I had been looking forward to total immersion.

Heather had mentioned reading in the Triple-A book about a beach near Layton, so I decided to try my luck there. Heading back south on I-15, I turned off at the Antelope Island Recreation Area ($8.00). A seven-mile drive along another sulfurous stretch and a long bridge brought me to the actual island; a mile and a half beyond was the "beach." It was a lovely beach up to a point—but then you have to walk about four hundred yards to get to the water, a long slow march that gave me a great deal of respect for the pioneers who crossed it and the Mormons who decided it was a good place to stay. At the water's edge there were millions of tiny flying bugs that swarmed with an audible buzz at knee level and moved in waves across the coastline. The water was still and rank and coated with brine flies; they floated and skimmed the surface. Better not to think about it.

I walked out in the lake a considerable distance and found myself only in thigh-level water. My mouth was clenched closed and my hands were covering my nose. I was squinting in an effort to keep all the bugs out of my eyes. I couldn't go on, and it seemed like miles before I would reach a spot in

the Great Salt Lake that was actually swimmable. So instead I just sank down and floated. What they say is true: the salt lifts you up and holds you buoyant. You can fold your legs to your body, make a ball, and bob in the water without going under. You can sit as if in a chair with your shoulders emerging from the bug-strafed surface. You can stretch out, put your hands above your head as if you were on a raft, and just lie there, facing the high but setting sun, listening to birds land and take off a few hundred yards away. The bugs on the water's surface are silent, and if you close your eyes it's easy to forget that mosquito larvae may be lodging themselves in your crevices, waiting to erupt and give you West Nile virus. I stayed out there as long as I could once my buoyancy experiments ended. I did it to say I had done it; the experience itself could be described as unpleasant but tolerable.

Only one other person, a man, was in the water with me, but as I traversed the beach on my way back to the car, I ran into a group of middle-aged Italian tourists, who shouted "Wonderful!" and "Arrivederci" as a Canadian couple tried to converse with them. As I walked back from the water's edge, the salt dried on my skin, coating the tiny hairs on my body and forming rivulets down my thighs. With every step or arm movement, I cracked a little bit. The tips of the arms of my sunglasses—which I had worn in the water—were covered with dried salt. My hair crackled. I licked my shoulder, then worried that I had eaten larvae. The lake water had been uncomfortably warm, but the showers outside the restrooms were blissfully cool, and I stood there in the twilight for a long time.

I drove back to Salt Lake City. The setting sun turned the sky at the horizon a deep red and reminded me of the red herring at the blindingly white *Spiral Jetty*. Robert Smithson originally picked the site because of its red color, the result of a peculiar combination of algae and organic chemicals in

the water. He had heard that the water in the Great Salt Lake "north of the Lucin Cutoff, which cuts the lake in two, was the color of tomato soup. That was enough of a reason to go out there and have a look." After visiting a few different locations, he found himself at Rozel Point, the eventual home of *Spiral Jetty*. "On the slopes of Rozel Point," he wrote,

> I closed my eyes, and the sun burned crimson through the lids. I opened them and the Great Salt Lake was bleeding scarlet streaks. My sight was saturated by the color of red algae circulating in the heart of the lake, pumping into ruby currents, no they were veins and arteries sucking up the obscure sediments. My eyes became combustion chambers churning orbs of blood blazing by the light of the sun. All was enveloped in a flaming chromosphere; I thought of Jackson Pollock's *Eyes in the Heat*. Swirling within the incandescence of solar energy were sprays of blood. (in Cooke and Kelly, 9–10)

Blood has now turned to bone; the streams of red algae dried into hollow, bleached beds. I thought of James Joyce and the "spiral ear," of "signatures of all things I am here to read, seaspawn and seawrack, the nearing tide, that rusty boot. Snotgreen, bluesilver, rust: coloured signs. . . . If you can put your five fingers through it it is a gate, if not a door. Shut your eyes and see" (Joyce, 31).

Chapter 2 } Sun Tunnels

The morning after my *Spiral Jetty* foray, I was ecstatic. So far I was doing exactly what I had set out to do. I had left Chicago with some trepidation, but I had pushed through 1,664 miles and hit my first landmark. Flush with success, I spontaneously decided to try and find Nancy Holt's *Sun Tunnels* (1976). Holt was Smithson's wife, an artist in her own right, who shared his drive to marry the natural world with the personal artistic statement. The *Sun Tunnels* are four giant concrete tubes (eighteen feet long and about nine feet in diameter) in the middle of nowhere, positioned such that at dawn and sunset on the summer and winter solstices, the sun rises and sets in alignment with the tubes; they perfectly frame the sun. At other times, holes in the sides of the tubes form constellations in their interior when the sun shines through them.

I liked the idea of this temporal precision—and the uncertain nature of the work's existence for the thousands of minutes every year that it isn't registering those specific astronomical alignments. Like *Spiral Jetty*, the *Sun Tunnels* are about time in its broadest sense, but while *Spiral Jetty* undergoes a constant process of evolution, the *Sun Tunnels*, with their exact and limited focus, are kind of worthless; they exist only as an idea most of the year. This seemed a productive combination of site-specificity and conceptual art, a work that asks the question of whether an idea is enough and of how "relevant" a work has to be throughout the duration of its life.

Both Lily, the artist, and Heather, the landscape architect, had mentioned the *Sun Tunnels* the day before as another work worth seeing while I was in the neighborhood, the "neighborhood" in this case being not a few square blocks but rather a few hundred square miles. I was up early, still tasting of salt, gassed up the car, and went to the nearest hotel lobby that advertised itself as a wireless Internet zone. The *Sun Tunnels* hadn't been on my original, vague itinerary, and such was the state of my research that it was all conducted in the lobby of the Sheraton Salt Lake City. Crouching over my laptop in an easy chair, I waited to be discovered as a wireless interloper.

Two hotel managers did in fact amble over while I was sitting there in my shorts and T-shirt. We had an extended discussion about my iBook; they asked me how I liked it, and I told them that I loved it with a passion I've rarely felt for a human. Then they asked me how I liked my room. I couldn't figure out if their friendly computer talk was a way to lull me into a false sense of security before they slapped the handcuffs on me or threw me out the front door next to the valet stand, or if they were just being friendly in a Western/Mormon sort of way. Suppressing the urge to say, "OK, I'm not really staying here but I needed the wireless access," I told them that I loved my room too and was finding it very comfortable. This seemed to satisfy them and they walked away. My Google search unearthed two different sets of directions to the *Sun Tunnels*. I scrawled them down and headed back out of Salt Lake City.

On the way out of town, I stopped to buy and mail my sister a birthday card. Standing at the cash register at Wal-Mart, I realized I didn't have my wallet. I pawed frantically through my pockets and bags while the cashier looked on unsympathetically. No dice. I ran out to the car and searched the floor. Nothing. Back to the gas station. Nothing. It could only be at the Sheraton, so I hightailed it back there to pull up the cushions of the chair I had been using. Nothing. I asked the

desk clerk, who directed me to one of the managers who had grilled me earlier. Nothing. He asked for my room number—in an accusatory tone, I imagined—so he could ask the cleaning crew if they found it in there. I slapped my head in a mock Eureka! moment and said, "I remember! It's in my glove compartment!" and beat it away from the front desk. Leaving the hotel I took one last swing past my research center. My wallet was under the chair. It was really time to get out of there.

I should have taken this incident as an omen, but I didn't. I blithely headed off, once again traveling west on I-80. Holt's tubes were supposed to be near an abandoned town called Lucin. Lucin is in Utah, but to get there you have to cross the salt flats and the Nevada border, go into Nevada about thirty miles, and double back to Utah on state roads. The salt flats were one of the most desolate stretches of road I've ever driven, and that should have been an omen too. Even Utah's tourism Web site says, "Imagine a place so flat you seem to see the curvature of the planet, so barren not even the simplest life forms can exist. Imagine the passing thunder of strange vehicles hurtling by on a vast dazzling white plain. This is not an alien world far from earth; it is Utah's famous Bonneville Salt Flats!" *Flat, barren, devoid of life, alien.* Who is writing this marketing copy? But what the description lacks in allure, it makes up for in accuracy. There's a hypnotic quality to the salt flats, a hundred square miles of literal nothingness, the monotony broken only by road signs exhorting, "Stay Awake!"

From my multiple visits to the Donner Pass Memorial State Park, I knew that it was in part this place that brought the Donner-Reed party to its fate. The families had tried to cross the salt flats as part of the "Hastings Cutoff" to California. The flats not only killed their oxen and forced them to abandon many of their wagons but also slowed their progress so much that the group arrived in the Sierra Nevadas weeks behind schedule and well into snow season. Various

documents and histories describe their experience crossing the salt flats in gruesome detail, driving near-dead oxen on in a failed quest to find water, hallucinations brought on by the shimmering heat and undifferentiated plain, the gradual abandonment of animals, supplies, debilitated wagons. I have remembered for decades now the closing words of the Donner Pass filmstrip, read from the diaries of thirteen-year-old Virginia Reed: "Hurry along as fast as you can and don't take no cutoffs!"

It was raining, the expansive sky of yesterday replaced by a dismal, gray drizzle. I was spared the "dazzling white plain" of the marketing copy and instead struggled to stay awake through the monochrome gray landscape. I-80 runs like a low bridge over the flats, as if passing over a giant motionless body of water. It was a weekday and the only other vehicles on the road were commercial trucks. I longed for passenger cars, feeling a bit out of my element and truly dislocated for the first time in all my driving. My car seemed like an atom lost in a vast universe, my quest—for something I had rarely even seen pictures of—a little scary and futile. I had two conflicting sets of directions, no idea where I was going, and no late summer sunshine to buoy myself.

The flats end abruptly at the base of the hills that form the western edge of Utah and turn into hills and mountains as you enter Nevada. Throughout the salt flats, road signs count down the mileage to Wendover (technically West Wendover), a flashy little gambling outpost just across the border; beyond Wendover, they list Reno, four hundred miles to the west, as the next noteworthy destination. My parents live near there each summer, and the baby in me wanted to forget the whole thing—the rain, the monotony, the *Sun Tunnels*—and keep driving, through Reno and on to their house in Truckee, California. I divided the distance by my speed and figured I could be there for the 5 PM episode of *People's Court*. My dad would

make me a vodka tonic, my mom would lend me a mystery to read, and I could sleep that night—just a few days into my experiment with solitude—in a familiar bed.

It was a failure of resolve even to think these thoughts, and a triumph of perseverance not to follow through on them. I knew I couldn't live with myself if I folded and wound up at my parents', so instead I noted the billboard outside Wendover for the Red Garter Casino and Hotel ($22 a night) and filed it in my brain as the most likely overnight option. Find the *Sun Tunnels*, commune with them, hit the Red Garter, and then press on to Michael Heizer's *Double Negative*, in the southern tip of Nevada, the next day. With any luck I'd be playing blackjack, cautiously, in a cheap casino by dinner time.

I skimmed thirty miles into Nevada until exit 378 for Montello/Oasis. Oasis turned out to be two abandoned buildings just off the interstate, one with a fading "Oasis" painted on its roof. I followed the two sets of directions, which at this point still agreed, going north on NV 233, thinking, foolishly, that the *Sun Tunnels* would be no less accessible than *Spiral Jetty*. Perhaps Lily and Michael and Heather and Bill and the two architects were already out there taking pictures! It would be a reunion! Then we could all go into Wendover and have a good time at the gambling tables!

After about twenty miles, I came to Montello, population sixty-six. There was a post office, two bars, and a gas station, which already made it livelier than Oasis and many other places I'd passed that day. In four blocks I was through the town, wondering if I should stop and ask directions. In the end, my emerging sense of adventure and my confidence, despite the inconsistencies, in the two sets of directions won out and I continued into the country without double-checking anything.

After Montello, this rarely traveled road becomes a scarcely traveled road. I may have passed three or four cars or trucks in twenty miles; meanwhile the rain continued and thunder-

clouds gathered. Both sets of directions told me to look for Grouse Creek Junction, which one set said was fifty-two miles total off I-80. I started looking for a creek bed, figuring there must once have been a Grouse Creek, but this was high desert and the only plausible candidate was one long ditch. It turned out that Grouse Creek Road wasn't hard to find—it's one of the few dirt roads I encountered that had a sign identifying it. I turned right, as instructed, and into the oncoming storm. The first set of directions said simply, "turn right toward Lucin Utah" (I had now crossed back into Utah); the other said "turn right and go 3.42 miles." It was now about 1:30 in the afternoon; I had passed into the Pacific time zone.

The road off NV 233, while rutted and jarring, was in slightly better condition than the road to *Spiral Jetty*. The sky was making me nervous, so I drove as quickly as I dared. Though my directions diverged pretty wildly, both cautioned drivers that the route to the *Sun Tunnels* was "rough" at best and "impassable" in the rain for anyone without four-wheel drive. I wanted to hurry. I hadn't crossed the salt flats for nothing, but I didn't want to get stuck out there either. Constant checking on my cell phone screen revealed that there had been no coverage since I had left the interstate more than an hour ago. The rain grew stronger.

I bounced along, continually comparing the directions, laid out side by side on the dashboard, and scouring the landscape for two different sets of markers and trailheads. There was absolutely no signage, nothing to suggest that I was even on a viable road. There was either one road or many roads—brush and rocks continuously divided the trail and created new little roads that would then peter out, some sooner and some later. No path looked particularly well traveled. Nowhere did I see a Subaru with a picnic lunch spread on its tailgate and fellow art pilgrims beckoning me over for a beer. In fact, I saw nothing but lightning. I checked my directions. I

checked my cell phone reception. Neither was encouraging.

I thought I had stumbled upon the right track when I passed a beat-up sign that said simply "Lucin." Hallelujah! Though Lucin Road turned out, I think, to be no more than an unused railroad track, at least I knew I wasn't completely lost. I was next instructed to look for "TL Bar Ranch Road," with no indication of how far it might be from the hard-won Lucin sign. So I just kept driving. I could feel my car beginning to resist, idling high every time I stopped to puzzle over my route. The car felt like my heart—starting to thud, running fast. I would be looking so hard for the TL Bar Ranch Road sign that I wouldn't notice veering off onto a very soft shoulder and floundering there as if I were in a Moroccan dune buggy race. I crossed creek beds and gravel washes, and each time I came up a rise I expected to see four concrete tubes sitting incongruously in the mountainous desert. Instead I just saw more mountainous desert, more lightning, fewer and fewer signs of civilization.

After a rise and a dip, well into the part of the drive where I was negotiating with myself ("If you don't see a stinking *Sun Tunnel* after the next three hills, you are turning around"), I ran smack into a herd of cattle just . . . hanging out. I assumed they were part of the TL Bar Ranch, though no sign designated them or the land as such. I also started to worry that I was in the middle of someone's property, someone who would soon come racing across the desert in a truck, shotgun resting in his lap. Maybe he would let me go, or maybe he would assault me out there where I could scream my head off and no one would hear. The picture of my desiccated carcass lying at the side of the *Spiral Jetty* road was replaced in my head by the picture of my brutalized carcass being picked over by cattle. Do cattle eat humans? I think they're vegetarians. More important, do they charge? Not one of the animals even lifted its head as I came up over the rise, but they were suddenly

within a few feet of my car. Knowing very little about cattle, I couldn't guess if they were a greater threat than the imaginary landowner with a thing for trespassers.

I drove on past the cattle, grateful at the very least that they now served as a marker. The herd was about twenty minutes from the Lucin sign; the Lucin sign was about forty minutes from NV 233. I was really starting to hate the *Sun Tunnels*—stupid idea, bad execution, piss-poor location scouting. I went up and over another rise, then another, then another. I did this for an hour, bumping along and keeping an anxious eye on the clouds and the rain. One set of directions told me that the *Sun Tunnels* were about ten miles past the TL Bar Ranch Road, but since I hadn't found that road I had no idea if I was even getting warm.

Now I truly began to panic, not even sure how to turn around and head back through so many wandering half roads with no landmarks. Though I have run and driven plenty of miles in my life, I had no real idea of how long a mile was until I tried to drive ten of them in unpaved terra incognita. A

mile of deep ruts takes a long time to drive; a mile piled on other unmarked miles seems an eternity. Yet I kept going. The storm continued to threaten, and after two hours off NV 233, I still couldn't tell if I were anywhere close to the *Sun Tunnels*. I kept expecting to turn a metaphorical corner and find them, but my native optimism was being replaced by a gut-level fear that for every mile I continued to travel, I would have an exponentially harder time finding my way out. It was coming up on four o'clock. If I didn't turn around soon, I would be trying to get back to the main road in the dark. But what if I turned around, then found out, years later, that I was less than half a mile from the damn *Sun Tunnels*, that I had missed them by a hair?

I finally gave up after another forty-five minutes. I had long ago turned the music off in the car, as if it was somehow retarding my search for the concrete tubes. It had now been hours since I had seen another car or had any cell phone coverage. I had driven my car practically into the ground, spinning through mucky gravel in a constant cycle of climbing

little rises only to encounter a blank landscape on the other side. I had spent the afternoon increasingly rationalizing the decision to turn around, arguing to myself, "They're just four concrete tubes that really only do what they're supposed to twice a year. I didn't plan to see them, and I'm out here in the rain, so what's it going to matter if I turn back? It doesn't matter. It doesn't matter. It's OK. Turn around."

And eventually I did.

As soon as I executed my U-turn, a huge white truck, from out of nowhere, blew past me. I thought it was a sign—if I followed this truck, I could find my way out. And as soon as I turned around, I felt better. The skies even opened up. The storm was literally behind me.

I followed what I could see of the white truck and its dust cloud all the way back to NV 233. When I hit that paved road, all of the tension drained out of my body. I felt immediately relieved. I hadn't found the *Sun Tunnels*, but at that point I didn't care. I wanted to drive away from the storm, back to civilization, and—this was critical—back to the bars I had

passed on the way in. Hours spent lost on rutted gravel roads had taken a toll on my nerves. Before I could consider what my next move would be, whether to Wendover or further south, I needed to relax.

I had seen two bars in Montello, the Cowboy Bar and Grill and the Saddle Sore. I don't know why, but I picked the latter. It was a one-room place with a glass door, a pool table right in the front, a bar running down the west side of the room, and video slot machines along the east side. On the back wall was a bumper sticker that said, "You wanna get laid? Crawl up a chicken's ass and wait!" I made my way past some guys playing pool—some white, some Mexican—and sat down at the bar. As I was sitting down, I saw an old man jerkily getting up and down from his stool at a slot machine, lurching around not in a drunk way but in a neurologically wrong way, a kind of physical Tourette's. No one spoke to him. The bartender, a tiny older woman with a wardrobe and makeup that dated, subtly, from the 1960s—got me a Bud, which I had chosen based on the layer of dust on the bottle of cheap vodka on the back bar. She was friendly and could tell I wasn't from around there, so she asked what I was doing. I told her that I had been looking for the *Sun Tunnels* but hadn't found them.

Hearing this, an older man who looked like Harry Dean Stanton but with a more sunken face cut in and tried to explain where I had gone wrong. Apparently there was a fork I didn't "go straight on" somewhere out by "Henry Jay's trailer." "It don't matter, though," he said. "Those things aren't worth nothin' anyhow." I dismissed his art historical opinion and instead thought, "God, I didn't even see a trailer."

"I can get you there," he kept insisting. "Hang on, hang on." He went down to the other end of the bar to ask another gentleman— respectable-looking in a Larry Hagman–*Dallas* sort of way—where I had gone wrong. He turned over his shoulder to say, "R. O. built all those roads out there, he should

know where these things are." They had a brief conversation, after which Harry Dean Stanton returned.

He told me that for fifteen years he had been the water master for Montello. In addition, he was the town's unofficial guide. Decades ago parcels of land were selling for practically nothing—two and a half acres for fifty dollars down and fifty per month for a few years. Plenty of people bought property without ever having seen it, so they would come out to Montello and for twenty dollars he would introduce them to the part of the West that they owned. I felt he was angling for an invitation, so I halfheartedly asked if he would take me to the *Sun Tunnels* for twenty dollars, knowing full well that I wouldn't go with him if he accepted. I was relieved when he said no. "I haven't been out there in fifteen years. I'd be as lost as you was driving on in there." He also said it was too late in the day and too wet after the rain: "It'll be mud dark." But I could tell this baggy old man appreciated my interest, and I felt I might have made a friend in this rough bar.

Harry Dean Stanton then sort of took me under his wing. He introduced me to a few people and bought me a second beer. Introductions made, he wandered out of the bar. About that time, the tiny bartender's replacement came in. His nickname was Maurice, and though he was tending bar on a Thursday night, his real job was as chief of police of Wendover, the casino town on the Utah-Nevada border. Maurice was born and raised in Montello and still worked the bar for fun. He said he was fifty-four, but I thought he looked much older—a weathered face, balding, a sparse mustache, and ears that stood out comically.

I sat at the bar and talked to Maurice. Or rather, he talked, and talked and talked. He talked about the history of Montello, a town built and owned by the Southern Pacific Railroad in the early twentieth century, so much of a company town that you couldn't get electricity if you didn't work for

Southern Pacific. The town remained a railroad town for much of its history; even today, a railroad track runs parallel to the main street, and while I was there it was lined with (stationary) railcars. Eventually, of course, Montello was forced to find a different economic platform, and that was mining. Three phosphate mines opened in rapid succession outside of town—the Franklin, the Delano, and the Roosevelt—but they stopped being productive in the 1960s. (This, of course, is Maurice's version. I could only later confirm the existence of the Delano, which opened in the 1870s, making the FDR triumverate unlikely.)

Listening to Maurice, I began to enjoy myself for the first time since leaving Salt Lake City that morning. He exemplified the thing I love most about bars. A bar is the only place you can walk into in a strange town and find some conversation about something unfamiliar. Bars are safe and cheap, and you can more or less leave at any time. Sitting there on that cracked bar stool, I realized that my time in the Saddle Sore was exactly what I was looking for on this trip. I was learning the somewhat offbeat history of a tiny town in a part of the country I had never before seen. Maurice was funny, pleasant, deadpan, and chatty. I was having exactly the "local experience" I wanted.

Maurice continued to talk. Despite spending most of his time in Wendover because of his job, Maurice remains committed to Montello, past and present. He is the town's historian. As a policeman he was required to attend conferences and legislative sessions in Carson City and Reno, which he had done with glee when he was younger, taking the opportunity to "raise hell." But as he got older, he said, "raising hell" had started to seem like a waste of time. So instead of hitting the casinos and the glitzy bars, Maurice started using these trips to better understand his history, going to state libraries and archives when not attending sessions.

One research project particularly affected him—his attempt to identify ten soldiers who were buried in the town cemetery in 1918. The soldiers were on army transport trains heading east on the Southern Pacific line during the influenza epidemic of 1918. They got sick along the way and were offloaded in Montello—without documentation—to prevent influenza from spreading throughout the trains. All ten died, and since these were the days before dog tags, or so Maurice said, no one knew who they were. Maurice had tried for years to find out but never succeeded. As far as he knows, the army failed too, "else why would they still be in Montello in anonymous graves?" To this day the ten soldiers are buried under headstones that say simply "Army 1918." Not knowing who these men were has haunted Maurice, as he is sure their untold deaths haunt their families. I liked him immensely after hearing what he had tried to do for these long-dead men. Regardless of the outcome, it was a noble and selfless effort.

Maurice said that it was family history that spurred him to start poking around in archives and libraries in the first place. Apparently his aunt and grandmother were killed by a jilted suitor after a dance in the 1930s. His aunt was "going" with one guy, and one night they went to a dance in a nearby town. At some point in the evening, another prospective suitor showed up at the dance with something marvelous—one of the first cars in the area. Enchanted, his aunt left the dance with the automobiled prospect to go for a ride, leaving her date alone at the dance. He showed up, enraged, later that evening at Maurice's aunt's house, shot the aunt in the chest, and killed her; the bullet passed through her and lodged in the head of his grandmother, who died in a hospital in a different town three days later. The killer was never found, so Maurice started digging around, and each historical trail led to another question. He says he can't wait until he retires and can spend more time being this sort of "detective."

Maurice also spoke a great deal about his job in Wendover, a vacation town of nickel slots and two-dollar tables. The big problem, from a "police chief standpoint," is crystal methamphetamine. Maurice said that people have always liked to come in and gamble and have a good time; win or lose, visitors were generally easy to control. But then crystal meth showed up. It's the worst plague Maurice has ever seen; it has made his job harder, as he approaches retirement, than it was when he started decades ago.

"How can you tell when someone's high?" I asked him. Maurice liked lists, and he made a lot of them. (Harry Dean Stanton liked lists too; when I asked him what animals were out here in the country, he counted on his fingers, "Elk, cougar, antelope, jackrabbits, I already said elk, I think, cougar . . .")

Maurice grew very animated. "Tweakers, well, you always find three things with tweakers. One, forged checks. Two, identity theft. Three, pornography. Oh, and I forgot one, poetry."

I was confused. "Poetry? They read poetry?" I imagined a drug addict sprawled on a dirty couch, Jerry Springer on the television, a Norton *Anthology* hanging from listless hands.

"No, no, they write it. Pages and pages and pages of gibberish. Tweakers, see, they have all this energy and they don't know what to do with it. I will bet you that in every tweaker's home you'll see a TV, or a washer, that somebody's tried to take apart and put back together so that it'll work better. Tweakers, they don't know what to do with themselves. They're on fire but they've got nothing to do."

Daniel, a younger guy sitting next to me, had been listening silently to Maurice but felt he had to jump in here. "Tweakers always have scabs all over them. That's what crank does. It gives you a complete system breakdown. You get a little cut, it doesn't heal, you start scratching at it, then it spreads and spreads and then they're all covered with sores. They're covered with scabs. That's how else you can tell."

Maurice, standing behind the bar, smoking a Leggett Slim and drinking a Keystone, nodded. "It's a really big problem. Started with women. Women want to lose all this weight, they start taking this stuff. It makes them feel so good because they're losing weight and they've got all this energy, but then they're hooked. And then their boyfriends get hooked, just to keep up with them. And then everybody's hooked."

Daniel agreed and added that the Nazis invented methamphetamines.

"No, it was the Japanese," Maurice said.

"Well, the Japanese may have invented it, but the Nazis were the first to use it to keep troops awake during World War II."

"The U.S. used it during Vietnam too. I took it then, did two tours. The army gave it to us to keep us awake. Everybody took it then whether they wanted to or not."

"The Japanese and the Nazis had different formulas."

"Yes, and the army's is most like the Nazis."

Maurice moved off down the bar to tend to other customers. Daniel leaned over conspiratorially and whispered, "I do meth all the time. It's not that bad." Daniel had short salt-and-pepper hair and the clearest violet eyes I had ever seen. They were mesmerizing. He worked as a casino dealer in Wendover and felt he knew it as well as Maurice did. I could tell that Daniel was angling for my attention, starting to argue with Maurice, to develop a side conversation with me. He bought me my third beer. But I liked taking to Maurice. When Maurice returned, I turned back to him and asked what kind of money Wendover brought in.

"One-point-five," Maurice told me.

"One-point-five million dollars for the year?"

"No, one-point-five million people a year coming in and out."

Daniel laughed. "One-point-five million dollars is a weekend."

Daniel lived in Wendover but said he liked to come to Montello for the fishing. This puzzled me as I didn't think I had seen any place one could fish while I was out searching for the elusive *Sun Tunnels*. But, on the other hand, he was wearing a T-shirt with a fish on it, so he probably knew something I didn't.

The conversation next turned to police work, which Maurice said essentially boiled down to psychology. "Policemen read people and situations. That's what they are trained to do. I been threatened a lot, but once you have this training, you know how to break down situations and defuse them."

He offered me yet another list: "You see, people have to have three things to really harm you: means, ability, and intent. Say some crazy guy is waving a knife at me, but he's across the street. Well, he's got the means, because he's got a knife. And he's got the intent, because it's planted in his crazy head that he should kill me. But does he have the ability? No, because he's across the street. But say this guy is standing next to me cleaning his fingernails with a knife. Does he have the means? Yes, he's got a knife. Does he have the ability? Yes, because he's standing right next to me. But does he have the intent? No, he's just there cleaning his nails! You always got to be working that equation. Always."

Maurice moved back down the bar and Daniel said, "Maurice don't know shit about people. He's gettin' a divorce right now."

Daniel and Maurice argued a lot. They argued over who invented methamphetamines; they argued over police tactics; they argued about strategic decisions made in Vietnam; they argued about Wendover. At one point they were arguing about whether a cougar will ever approach a human.

Daniel: "A cougar is never gonna come near a human. That's why when you're camping you're safe from cougars."

Maurice: "A cougar will approach a sick human and try to

attack it. They can smell something sick about a person, and they'll come on in and try to take advantage."

"What about cattle?" I asked. "Would a cow every charge a human?"

"A bull might . . ." Daniel offered.

"Might?! *Might?!*" Maurice started laughing. "That's what bulls *do*! No one's gonna go to a bullfight thinking the bulls *might* charge!"

Daniel reddened and turned to me. "What do you care anyway? Why do you care about cattle, city girl?"

So I told Maurice and Daniel about my afternoon searching for the *Sun Tunnels*. I told them I had been anxious out there, driving around aimlessly, getting lost in the rain, not seeing another human for hours.

"The code of the West," Maurice told me. "You hit up against the golden rule of the West. In the west, you either fix it or walk back."

I thought this was a pretty good summation of the attitudes I had always associated with the "mythical West," land of gunslingers and cattle farmers and Clint Eastwood in *A Few Dollars More*. Maurice's code brought together, quite neatly, ideas of self-sufficiency and detachment, a head-on approach to life very different from that of confused urbanites like me, who run with their ridiculous neuroses straight to the therapist. "Fix it or walk back" denoted competence, confidence, and the ability to take risks and worry about the consequences later.

I told Maurice that I was so unschooled in mechanics and so unprepared to walk miles in the high desert that I could neither have fixed it nor walked back through that rainstorm and lightning.

"Well, it's real smart that you turned around then. I remember I was out there once as a kid and I had borrowed my dad's truck. It had a big welder on the back of it. I was probably

fifteen, twenty miles from the nearest road that had any traffic on it. Sure enough, the truck broke down. And I walked all night to get back to the road. When I got home later, my dad beat the shit out of me. Not because I took his truck. Not because he had been worried when I didn't come home all night. But because I left that welder out there."

Maurice asked me more about my trip and could tell I was disappointed that I hadn't gotten to see the *Sun Tunnels*. He knew exactly where they were, and, if I were willing to stay the night in Montello, he'd drive me out there tomorrow morning in his restored 1942 army jeep. We would have to wait until a moving company delivered his furniture—his wife took most of what he had so he had to order new—but then he and I could just hop in the jeep and not only would he take me to the *Sun Tunnels* but he'd drive me around and tell me all about Montello history—"No charge," he was careful to add.

I had seen the town's motel on my way in. It was a dreary affair—no cars in the parking lot, weeds growing through cracks in the asphalt. I thought that my VW Jetta, all alone in the lot and with Illinois plates, would be a billboard announcing, "Here's the girl from out of town. Come on in and rape her!" There was no way I was going to stay over.

Nonetheless, I hesitated before saying no and offering some lame excuse. I wondered if this weren't precisely the type of experience I should be embracing. Wasn't I out here to meet "characters" like Maurice? I had spent hours talking to him in the bar, and I liked him; he seemed self-possessed, knowledgeable, and curious. And he was a police chief, after all. I had to admit that the idea of driving around that country in an open-air jeep appealed to me. I wasn't here to be overly cautious—in fact, one of the points of the trip was to stretch myself. But where was the line between opening myself up to new experiences and taking unreasonable risks? Was I going to spend the next few weeks saying no, being scared? If so,

shouldn't I just turn around now? I could be back in Chicago by the end of the week.

I wasn't sure what to do. My instincts told me there was too much to lose here, traveling alone for hours in an unpopulated area with a man I barely knew. But the ambitious part of myself told me it was going to be a long couple of weeks if I stuck to the safe route and lived all these miles out with anxiety and paranoia.

I decided to buy some time to further consider Maurice's offer and told him that though I had a schedule to keep (a lie), I would think about it.

Maurice said, "You do that, sweetheart," and moved back into a refrigerator for more beer.

Daniel leaned over to me and said, "I wouldn't trust that guy if *I* had a gun to *his* back."

"Are you saying I shouldn't go?" I asked.

"No way should you go. No way."

Maurice came back and set a beer—my fourth? my fifth?—in front of me. "On the house," Maurice said. "Hospitality to our neighbor from the big city."

I protested. No, I'd had too much, I needed to be able to drive out of there, I had to get going, I hadn't eaten all day, really, I should get going.

Maurice said they had a good kitchen. I asked if I could get a grilled cheese sandwich.

"*Goat* cheese sandwich? *Goat cheese sandwich?!*" Everyone who heard him started to laugh.

"*Grilled* cheese!" I shouted. "*Grilled* cheese!"

He pretended to wipe his eyes like he was laughing so hard he was crying, like it was the funniest thing he'd ever heard. "Sure, you could get a grilled cheese sandwich, but it would taste a lot better if there was a hamburger in it. Let me get you a cheeseburger. They're good. On the house."

I said OK and he placed a combination napkin/salt/pep-

per holder in front of me. There was a Dymo label on it that read "For Sale." In a few minutes Maurice brought me the cheeseburger. It was far from good. The tomato and lettuce were fresh but the meat itself was kind of mushy, the worms of ground beef that come straight out of the package still visible. I ate about a third of it. After I hadn't touched the burger for a while, Daniel leaned over and asked if I was going to finish it. "You didn't eat much for someone who said they were hungry." I told him I was full up on beer. He asked if he could have the rest of the cheeseburger, so I gave it to him.

By now I had been at the Saddle Sore for about four hours. The crowd hadn't changed much, but the afternoon had turned to twilight, so light so late here at the edge of a time zone. My bladder was screaming, so I excused myself to go to the bathroom, taking my purse with me. When I came back, Maurice asked why I had taken my bag.

"Habit, I guess," I told him.

"What, you don't trust us?" Daniel leaned in again. "Do you think we'd steal your wallet while you were in the bathroom? With this guy, a police chief, standing right here?"

"I didn't think anything. I just don't leave my purse sitting on a bar."

"City girl likes to keep her purse all the time, right?"

"What's the big deal? I went to the bathroom, I took my purse."

"After all the stuff we've been telling you about what a good town it is, what good people there are, you don't want to leave your purse here?"

Maurice jumped in. "I get it, I get it. I went to Chicago to see my nephew graduate from college. The whole time I kept my wallet in my front pants pocket. I never do that, ever. But I did that whole weekend."

Daniel seemed satisfied with that. Someone turned off the news, which had been playing silently on the TV above the

bar, and replaced it with a country jukebox. Pool balls clicked and clacked against each other, chairs scraped, people laughed and joked. Music started to play. A Mexican guy came up to me, put one hand on my shoulder and the other on my left breast. "Dance?" he asked.

I said, "No thanks," as Daniel yelled, "Back off!" Again he leaned into me as the Mexican guy walked away. "I can take that guy out into the parking lot and beat the shit out of him if you want. Did you see that? Did you see what he did to you?"

I said it was no big deal. Daniel launched into a monologue about how he was put on this earth to "do battle." He doesn't like it, but it seems to be what he is destined to do. He complained that the Mexicans don't want to know anything about how the real world works; they just come in and grab what they want and they don't have any manners.

"But I'm a fighter, Ariel," he said. He had been calling me "Ariel" all night and I hadn't bothered to correct him. I guess it sounds something like "Erin."

"I will do battle for the right cause," he continued, a bit agitated. "It happens in the casinos all the time. Something talks to me, makes me want to get in there and set things right."

I pretended to sip my beer and enjoy his company but in truth I was growing nervous. I had drunk too much cheap beer, I had been publicly humiliated for ordering a goat cheese sandwich, and my sense of personal safety had been challenged. A stranger had touched my boob. And now I found one of my two allies in this bar talkin' loco. What kind of protection was Daniel? A crankhead who would beat the shit out of a Mexican in a parking lot to defend Ariel's honor?

In my beery haze, I was becoming convinced that Montello was a spider drawing me into its web. Maurice's hospitality began to seem ominous; Daniel's attentions, which started out kind of sad, began to seem threatening. The wisest course of action, I thought, would be to leave as soon as possible. But

I didn't think I could just pick up my purse, say good night, and be on my way. There were too many threads still hanging. Maurice would ask me what I'd decided about going to the *Sun Tunnels* with him tomorrow; Daniel would ask if he could walk me to my car, making for more uncomfortable moments with him.

No, I couldn't face wrapping up the evening in a mature manner. *Leave without telling anyone,* my wet brain instructed me. I imagined, ridiculously, these lonely romeos chasing me in pickup trucks across the salt flats. The air was filled with smoke, the music was loud, and my head was starting to ring. All the enthusiasm I had felt for being "out West"—seeing *Spiral Jetty* and having "deep" conversations with architects and artists, floating in the Great Salt Lake, eating great almond mole alone in a restaurant in Salt Lake City—drained away, and I saw myself for what I was, a tiny drunk thing who didn't know where she was going, sitting in a dive bar filled with oversolicitous and, at moments, hostile men.

Another twenty minutes passed. I felt frozen with fear. Daniel talked about his ex-girlfriend, "a very nice lady who couldn't put up with the hell-raising." He asked for my phone number. It was another juncture where things could grow even more uncomfortable. If I gave it to him, he'd have my phone number. If I didn't, he might be angry or embarrassed—two states of mind that I didn't want to see him in, especially after the incident with the Mexican guy. So I did what any self-respecting woman in a bar would do: I gave him the wrong number. Except that, out of reflex, I gave him the right number. I had meant to switch around some digits, but instead my cell phone number just rolled off my tongue, perfect and whole.

Terrific. Now he had my phone number.

"Ariel, this is great. I'll check in with you to see how you're doing on this great trip of yours. Great."

Things had gone too far. I finally made my move. I made a big show of grabbing my purse and said, "Well, time to hit that bathroom again! OK with you guys if I take my purse?" Luckily the bathrooms were near the front door. I slid off my stool and tried to saunter casually—past the dancing Mexican couples, past the guys playing pool, past the shuddering form of the lone guy at the slots along the wall—to the front of the room. At the last moment I veered left instead of right and found myself, heart pounding, in the parking lot. I was immediately sober. I hustled into my car, started it up without the lights on, and literally peeled out of the parking lot, not even knowing where I was headed. I stopped in the middle of the main road for a nanosecond to take a picture.

Then I just started driving. I couldn't go to Wendover. Maurice worked there, Daniel worked and lived there. Going to Reno, or my parents' house forty minutes outside of it, had the stench of failure and childishness to it. And there was not much between Wendover and Salt Lake City—just 150 miles of salt flats and a few gas stations. Heading south toward

Overton, Nevada, the site of my next stop, Michael Heizer's *Double Negative*, seemed a big gamble. I would hit a few widely spaced hamlets but could find myself with no place to stay, far from an interstate. Las Vegas was only a few miles farther than Overton, but both were hours away, and it had already been a long day.

Confused, I decided to take the path of least resistance and drove like a bat out of hell back to Colonel Flagg and the Salt Lake City Motel 6. It would be my third night there. When I was twenty miles outside of the city, Daniel called me. I answered the phone because his area code was only one digit off from my area code in Chicago, and in the dark car I thought someone was calling from home. Daniel, two hours after I had left, wanted to know where I had gone and whether I needed gas because, he said, "Ariel, I'm the kind of guy you call when you need gas." I told him I was headed to Reno.

Chapter 3 } Moab

I woke up late the next morning at the Motel 6, reeking of smoke and stale alcohol, with the kind of headache that only bad beer can produce. Though it was early in the trip, I was already exhausted. Each day had brought multiple cycles of anxiety and relief. The day before, seeking the *Sun Tunnels* but instead finding a black hole with bar stools, had been especially taxing. So I turned to the time-honored remedy —equally effective for a hangover or existential crisis—of remaining prone and watching daytime television. Flipping on the TV and seeing Judge Mathis's face, I felt an immediate rush of familiarity and comfort. And there I stayed, with Judge Mathis, until the last possible moment before checkout, at which point I made another impulsive decision: to go to Moab, Utah.

I had put hundreds of miles on the car in the past two days, looking for art and marveling at the sheer beauty of Utah, a state I'd never before visited. I wanted to get off the art tourism plan, clear my brain a bit, and enjoy some natural beauty untouched by an artist's hand or a casino dealer's views of humanity. I picked Moab because there were more brochures for it in the Motel 6 lobby than for any other attraction. Home to Arches National Park, Moab seemed a friendly, vacationy spot that would take me deep into Utah and offer a concentrated dose of the landscape that was enthralling me.

After a greasy breakfast at Denny's, I drove south out of Salt Lake City, a place I had developed a certain and sudden

affection for. Salt Lake City, home of surprisingly good Mexican food and my refuge after the events of the day before, had already become comfortable and familiar. I was amazed at how quickly this city became a sort of home to me. I knew the layout, had my friends (motel clerk, Colonel Flagg), and had set up domestic arrangements (Motel 6, second floor, west side). It felt not unlike moving into a new apartment. For the first few days, one is very alienated, lying awake at night listening to strange noises and trying to come to terms with the new light patterns that play across the bedroom ceiling. But then, almost imperceptibly and within days, the new place becomes home and the old place is forgotten. A new routine is established; the pots and pans find new spots; and a drive past the former home seems a visit to a different country.

Moab is about 230 miles southeast of Salt Lake City—south on I-15, southeast on Utah 6, east on I-70, then south on 191. The urbanity of Salt Lake City drops away quickly, and the landscape grows empty. The day was very bright, but clouds were starting to amass, first white and then gray, and rain showers could be seen at various points along the route. Though Utah 6 is a major thoroughfare, second only to an interstate, it was quiet and largely unpopulated, with only a few commercial trucks and even fewer passenger cars. Wondering about this, as I wound down roads generously carved between mesas and ridges, I realized I had no idea if it was a weekday or a weekend.

Having held office jobs for a good part of my adult life, I was thoroughly attuned to working-man's time—the melancholy of Sunday night, the gloom of Tuesday afternoon, the sweet relief of Saturday morning, the changing light in my office between 10 AM and lunchtime. Just as trackers and hunters in the old west could sense the presence of a bear or the imminence of rain, I knew—in my own environment—what day and what time it was without having to check a calendar or

clock. But away from the urban canyons and the shadows on a computer monitor, on a trip like this, these ingrown skills were ultimately useless. Were there so few passenger cars because it was the middle of a Thursday? Or was it Friday, but no one in Utah goes away for a weekend? Counting on my fingers the days that had passed since leaving Chicago, I determined what a week ago I'd have known without thinking—that yes, it was Friday, and moreover, that it was Labor Day weekend, when one would expect a lot of people to be on the road. But they weren't.

I called my friend Todd when cell phone reception kicked in again to tell him where I was heading. "Moab is my wash-pot," he kept repeating. The line is from a psalm, apparently, and the title of a book, but I had never heard the word "Moab" before seeing it on that brochure rack at the Motel 6. I had done preparatory reading about Utah before the trip—study-ing up on the salient aspects of each state I would visit—but, as my reading for pleasure tends toward the dramatic and sa-lacious, I had versed myself only in the bloody and incestu-

ous histories of Mormonism for the Utah leg. So while I could recount Jon Krakauer's description of a series of heinous, religiously motivated murders in Utah a few years back, I was blank on anything not having to do with polygamy, magic tablets, and meditating in the wilderness.

While Moab is not even mentioned in Krakauer's *Under the Banner of Heaven*, the town, I would learn, was a significant part of Brigham Young's grand plan. While busy settling the northern part of the state, Young and his council also wanted to control the Indian population in surrounding areas. To this end, he sent a party of twelve men south in 1854 to set up an outpost along the Old Spanish Trail. Near what is now Arches National Park, the men had to dismantle their wagons and lower them down an escarpment; derailed by the difficulty of the terrain, they abandoned their wagons but continued on to the Colorado state line. Because this first party had failed, a year later Young sent forty-one men to the same area, where they established the Elk Mountain Mission. The task wasn't without its dangers; the valley where Moab is now, and where the earlier party had left their wagons, was a gathering ground for the Ute and Navajo Indians. An uneasy truce was struck but it broke down quickly, resulting in a skirmish between the Mormons and the Indians. Two missionaries were killed, and the Elk Mountain Mission was abandoned not long afterward.

For nearly three decades the Mormons more or less left the valley alone, but it was gradually and loosely settled by cowboys and ranchers, according to the official city history. A Mormon ward was established. I guess the third time *is* the charm. In the 1880s it got its post office and was officially named Moab. Most accounts say it was named for the mountainous region east of the Dead Sea and southeast of Jerusalem, which some thought corresponded to the Utah Moab's geographical relationship to the Great Salt Lake and Salt

Lake City, the epicenters of the territory in the nineteenth century.

Some claim the name came from a Paiute word for "mosquito water." But the biblical character Moab, who gave his name to the land of Moab, makes for a far more interesting derivation, especially in relation to Mormonism. Moab was the son of Lot and one of Lot's daughters. Living in seclusion, Lot's two daughters realized the end of their lineage was near as "there is not a man on earth to unite with us as was the custom everywhere" (Genesis 19:31). They cooked up a plan to get their father drunk and have sex with him. Which they did, on consecutive nights. Both wound up pregnant; Moab was the offspring of the elder daughter.

Moab had many descendents—the Moabites, of course—and their land became the last resting spot for the Israelites before they entered the Promised Land on their return from Egypt, and the place where Moses was buried. Which of these intertwined stories most appealed to the Mormons of Moab, Utah? Was it the link of Moab and the Promised Land that sold them? Or the fact that Moab was the product of an incestuous relationship?

In present-day Moab there is virtually no sign of the difficulties the Mormons had taming it. The area, which thwarted missionaries for decades, is one of the premier vacation spots in this part of the country. The town of five thousand hosts approximately a million people each year, the result of an energetic and clearly triumphant campaign in the 1970s and 1980s to make up in tourism what had been lost with the failure in the 1960s of the (mostly uranium) mining industry.

A four-hour drive from Salt Lake City takes you via lightly trafficked roads through phenomenal scenery—gradations of color that climb the ridges, spatial confusion brought about by experiencing the steep and the flat simultaneously, blue sky and bright sun that fill every mountain crevice and chink

in the geological armor. Finally one lopes into Moab as if into a shimmering oasis. When I arrived, the main street was filled with SUVs with hang gliders, mountain bikes, and camping equipment strapped to their roofs. En route, I had marveled at how empty the roads were; now I realized it was because all of the cars were already here. The visitors center offers literature on every imaginable outdoor activity and a Bible-sized directory of places to stay. There is, it seems, a hotel on every corner, along with high-end restaurants and spas, and a seemingly sharp division between "townies" and tourists.

To my surprise, there was also a distinctly hippie/surfer vibe to the place, but perhaps that was because it seemed to be populated primarily by white nineteen-year-olds with Aryan good looks and well-earned tans who lived for expensive dirt bikes. Everyone was young and active, not weekend-warrior active but the kind of active that speaks of real devotion to the outdoors, to the rush of physically pushing oneself on the river or the trails. And yes, it was Labor Day weekend. I could hardly have picked a worse day to arrive in this town that plays host to the rest of the West all year.

My first task was to find a place to stay; once I hit the main drag of Moab, as congested as any street in downtown Chicago on a Friday afternoon at 4:30, I realized that I could very well be sleeping in my car. The official Moab tourism Web site lists about thirty-five motels—including the Lazy Lizard Inn and every subspecies of chain hospitality, from La Quinta to Best Western to Holiday Inn to, yes, Motel 6. I made some dispirited inquiries at various places—all too expensive and few with vacancies—and then I hit the Redstone Inn.

The Redstone had one room left, complete with Internet access and cable TV. The proprietress and I discussed the poor timing and planning of my visit; she told me that the town had very few rooms remaining but that spots were usually available at the campground even during busy times. She pointed

out the window to the left, where I saw a sea of trailers and RVs. I pulled out my credit card with a vague sense of failure, the realization dawning that, though I was out here to challenge myself, I was on the verge of paying ninety dollars for the privilege of sleeping in an air-conditioned room, catching up on my blog reading, and being lulled to sleep by Jack McCoy's gentle yet preachy voice. Where was the adventure in that? I put away my wallet and signed up for a spot at the campground next door.

The campground was partitioned into two different nations, the RV nation and the car-camping nation. My people were separated from the RVs by about thirty yards. At first glance the campground looked like a mall parking lot with every other parking space filled; in the empty slots were tents of varying degrees of complexity. My tent, unsurprisingly, was not complex at all. At the last minute before leaving Chicago, I had made a hasty and expensive trip to REI for a tent, mattress, sleeping bag, headlamp, and mace. Here in Moab, I was excited to break them out—well, everything but the mace—for the first time. I had practiced putting up the tent in my living room, so I felt confident that I could do that quickly and with a minimum of embarrassment. What I hadn't counted on, though, were high winds and granitelike earth. No sooner would I telescope my tent up to its full height then it would start tumbling away. I knew I had to drive in stakes to keep it anchored; this, however, was an aspect of tent assembly that I had not explored in my living room.

I found the stakes and stupidly thought I could just stomp them into the ground wearing my Steve Madden microfiber wedge sandals. When that failed, I had a brilliant thought, a thought that demonstrated to me the quickness of my mind, the pioneer problem-solving ability that I knew existed, untapped, within me. Opening the trunk, I pulled out the Club, the anti-theft device I clamp to my steering wheel in Chicago.

Though the hammering surface is less than four square inches, I was convinced it was enough to drive the stakes into the ground.

The Club comes in two pieces, one of which slides into the other. When I tried to hammer in the stakes without locking the Club, I succeeded only in catching the meaty skin under my thumb in the groove between the pieces. I locked the Club and tried again, but kept missing the top of the tent stake, slamming the Club into the ground and sending shock waves up my arm, into my shoulder, and through my entire torso. Dust was blowing in my eyes and I was trying to hold the corner of the tent down with my foot; I dismantled the tent eventually but at the time didn't want to waste the effort of putting it up, taking it down, and then putting it up again. Of course I was being watched the whole time, and after about twenty minutes a grizzled older man who smelled like beer walked up, silently handed me a hammer, and returned to his picnic table.

I pitched my tent, gave back the hammer, locked the car, and started walking toward town. My first stop was a hardware store, where I bought a hammer. And since it was coming up on six o'clock, I thought I should eat. In anticipation of a long, cold night on the ground, I decided to reward myself with a "real" multicourse meal of grilled fish, good wine, and a rich dessert, which I ate alone without the benefit of a book or a magazine. I tried several times to engage the waiter in conversation, but though the restaurant was not even a quarter full, I couldn't get three words from him. So I ate with gusto but also with a sad self-consciousness because I was alone in a tourist town eating dinner on a holiday weekend while it was still light outside. Perhaps I should give Daniel a call, see if he could bring some meth down from Wendover and hang out with me.

When I finished, it was 6:50, still very early. I couldn't rally myself to, say, see a movie on Main Street or go to a lecture

on local geology at the community center. I really wanted to read, as lame as that sounds. I headed back up to my tent at the campground, about three-quarters of a mile from the center of things. While it was still light I sat in a beach chair between my car and my tent with a mystery in my lap. When it started to get dark, I used my headlamp for the first time. After another thirty minutes, the gadget's appeal wore a little thin. I was resignedly crawling into my tent for the night—thinking, "If I'm asleep by 8:30, I'll be awake to see the sun rise"—when I was addressed with "Hey, Neighbor Lady."

The voice was that of a nineteen-year-old guy, camped in the parking spot next to mine with a male friend and two quiet girls. God only knows what they had been saying about me as I sat in my beach chair, next to my car, wearing my lame headlamp. Perhaps they felt pity, because they invited me over for a Corona or two or three. They were well prepared for their weekend; they even had lime wedges to stick in the necks of the beer bottles.

As near as I could figure out after twenty minutes of conversation, the guys had brought these girls camping in the hopes of hooking up. The gregarious blond, whom I'll call Greg, had for some reason latched on to the more sullen of the girls, and he was making every sweet and clumsy effort to reel her in. Meanwhile, on the other side of the campfire, his friend was making off like a bandit with the brunette. Greg's choice remained aloof and silent while we sat around, drinking beers and telling ghost stories that bordered on autobiography. I told them about the Palehua night marchers in Hawaii. Greg related the story of a keg party in someone's basement at which a "spirit" had appeared to warn of trouble; wouldn't you know, the following weekend one of the dudes at the party wound up dead in a hunting accident. We talked about Stephen King and the ghosts of the Indians/Mormons/ranchers whose blood had been shed *perhaps in the very spot*

where we were sitting. In the course of our conversation, the friend and the brunette went from the laughing, hand-on-arm stage to the legs-touching stage to the underarm-nestle stage, while Greg kept striking out, his date constantly finding reasons to move away from him, leaning forward to tend the fire or rising repeatedly for another beer or a trip to the bathroom.

Finally, it was just Greg and me talking. The couple across the fire started to make out, tentatively and furtively, and Greg's would-be girlfriend started yawning and retired to their tent. Greg and I talked for a long time. He told me that all four of them had been raised as Mormons and that he and his friend had served in the army. Being Mormon was no big deal to them; it was their religion but nothing close to a way of life. I had asked him about it directly because, based on my careful reading of Krakauer's book, I didn't think Mormon kids went on coed sleepover camping trips and drank beer. Greg thought it was a nonissue. "There's a lot of different ways of being Mormon," he said, "and the army pretty much pounded most of them out of me."

They were a generous lot, especially Greg, who, despite his companions' obvious lack of interest, forged ahead from topic to topic. We talked until about midnight, at which time he offered me some of their dinner leftovers ("Didja eat yet? We've got some chili that's still warm") and offered to walk me the five steps back to my tent. When I declined, he said he was a light sleeper and would make sure everything remained OK in our little corner of the world. I didn't feel I needed protection here in the middle of the parking lot, but as I went to sleep, I did feel grateful that I could hear his low voice in their big tent, quietly trying to convince the sullen girl to share a sleeping bag with him.

I was up early the next morning because, well, everyone gets up early when they are camping, apparently. I was in my

beach chair, unwrapping my hundredth Balance Bar of the trip when Greg spotted me and asked me to join them for breakfast. He asked if everything was OK and said that during the night he had noticed a guy on all fours creeping around my tent. I was sure he was joking and asked if it might have been the ghost of a dead Indian, Mormon, or rancher. But then his friend said, "Yeah, I woke up too and saw some strange shadows around your tent. I thought you were getting up to go to the bathroom or something." I said no, that I had stayed inside the whole night, and began mentally inventorying my body to see if anything felt amiss. The guys looked at each other, muttering about the strange intruder. "Kind of a big guy, really," said the friend. My concern must have been evident to the more suggestible of the girls; she slapped Greg's arm and said, "Cut it out, now. She's all alone!"

The boys had made a huge meal of eggs and pancakes and coffee. Greg seemed the same, but his friend had the quiet smugness of a guy who knows he's going to get what he wants, if not on this trip then soon. Greg had struck out, I could tell; his girl kept a healthy distance from him. Really, the girls couldn't have cared less about me, nor could the smirking friend, but Greg seemed genuinely excited by my company and kept filling my plate with the great campstove breakfast. He offered to take me riding later on his dirt bike, which was on a trailer next to his truck, and I said I would love to go. At that point the sullen girl piped up and said that that's what *they* were supposed to do that day. What was she going to do if he was off riding with me? I didn't want to make trouble, so I backpedaled and said I was busy (which was ludicrous; as they all knew, I was just driving around for a few weeks without any real plans). At the same time, I was pleased that Greg was at least able to use my presence to get some attention from her.

Having said that I was busy, I packed up the car and took off, deciding to spend the day hiking Arches National Park. It

may come as no surprise that I am not much of a hiker. Faced with the eternal, self-defining question of whether one is a mountain or a water person, I always opt for water. Maybe it is the result of being a navy kid who was never very far from a coastline—family vacations every August on the Connecticut shore or in Ocean City, Maryland; high school years in Honolulu, listening in my bedroom to the surf pounding Queen's Beach, less than a quarter mile away, and taking open-water scuba as a legitimate P.E. course.

It's not that mountains intimidate me; it's more that they often come with forests, which I think of as bug-filled, cold places where bears tear the throats out of campers. In this regard, I found Arches perfect: the mountains without the forest. The landscape is filled with scrub brush and rocks, with hawks pinwheeling overhead and a vast and empty sky for company. Moab averages only eight inches of rainfall per year, a climate that doesn't support much in the way of vegetation. Everything is potential tinder, and the aridity lends the landscape a desperate quality, every bush or shrub a quiet testament to the successful struggle for life.

The roads and paths through Arches seem forlorn, losing their battles against the sand and dust and harshness. But against this stark backdrop is the most subtle coloration of everything around you; it is as if, in the absence of a broad spectrum of color, every leaf and rock and ledge has deepened and intensified itself within a small range. It seems rich and varied, like a million shades of white when you see them next to each other and realize what an ineffectual word "white" is.

At Arches there are very few edges; as with Robert Smithson's salt, time reveals itself in curves and layers and strata. It is not the three decades of *Spiral Jetty* that one measures in walking through this landscape but the deep sense of geological time, of rivers working their slow magic, ceaselessly rubbing away at the rock. There are no steep cliffs or heart-racing

drop-offs. Instead, sides of mountains just slide away, sinisterly soft and almost comforting in their biomorphism. I wandered the terrain, thinking of Miró's bubbles of landscapes and people, fixed blobs of space sharply defined yet with no sharp edges. In this climate of the slow and the long, it's hard to imagine something spontaneous happening—a landslide or an avalanche. The mountains have a leisurely quality, a solidity tempered by the passage of time, a quality completely different than the constant restlessness of the ocean, with which I am more familiar.

According to the National Park Service, the exposed surfaces at Arches date from the Pennsylvanian Period (300 million years ago) to the Cretaceous Period (145 to 65 million years ago). The Pennsylvanian Period is the era in which swamps filled with organic material and eventually formed the coal Pennsylvania is known for. Many geological periods are named after the sites in which time was quantified and

contextualized: the Permian Basin, Mississippi, Devon, Oxford, Maastricht.

I don't know if Smithson made it to Moab, but if he were out West looking for red I imagine he might have stopped here. Moab, at least when I was there, wasn't the fiery red of the Great Salt Lake at sunset, the red of tomato soup or blood spilling from earthen fractures. The red of Moab and Arches was deep rather than bright, subtle and various rather than loud and strident. Reading about it later, it was impossible not to think of the red as the trapped cries of muted life. John McPhee, the only "geologist" I've ever read, writes, in *Annals of the Former World*:

> There may have been a superabundance of oxygen in the atmosphere from late Pennsylvanian through Permian and Triassic time. As sea level changed and changed again all through the Pennsylvanian, tremendous quantities of vegetation grew and then were drowned and buried, grew and then were drowned and buried—to become, eventually, seam upon seam of coal, interlayered with sandstones and shales. Living plants take in carbon dioxide, keep the carbon in their carbohydrates, and give up the oxygen to the atmosphere. Animals, from bacteria upward, then eat the plants and reoxidize the carbon. This cycle would go awry if a great many plants were buried. Their carbon would be buried with them—isolated in rock—and so the amount of oxygen in the atmosphere would build up. All over the world, so much carbon was buried in Pennsylvanian time that the oxygen pressure in the atmosphere quite possibly doubled. There is more speculation than hypothesis in this, but what could the oxygen do? Where could it go? After carbon, the one other thing it could oxidize in great quantity was iron—abundant, pale-green ferrous iron, which exists everywhere, in fully five per cent of crustal rock; and when ferrous iron takes on oxygen, it turns a ferric red. That may have been what happened—in time that followed the Pennsylvanian. (29–30)

This theory is hard to grasp for a humanist like me without even a working knowledge of the simplest aspects of existence. But McPhee's language—*drowned and buried, drowned and buried*—suggests an agentless holocaust, the mechanisms of nature at her most cruel and oddly blameless. The harsh quality of the Moab desert is moderated by a strange kind of sympathy available only to those—like me—who can manage to anthropomorphize rock.

Moving, in the space of just a few days, from *Spiral Jetty* to Arches National Park, your sense of time whipsaws. Thirty-five years of salination and submergence—the time of the jetty—seems child's play when walking the trails of southern Utah. McPhee is at great pains to point this out: "Geologists will sometimes use the calendar year as a unit to represent time scale, and in such terms the Precambrian runs from New Year's Day until well after Halloween . . . the Roman Empire lasts five seconds" (89). To me this expanded vision of time is liberating, something I can call up when I begin to feel overwhelmed at work or stuck in my petty problems or angry about the president. *We are nothing, we are actually less than nothing.* Mr. Devlin, one of my high school teachers, used to say, "Look, kids, you think the dinosaurs were losers because they didn't last, but the dinosaurs were here a lot longer than *your* species is gonna be." I don't think I fully understood the immensity of that statement—and the smallness of our place in time—until decades later, in Moab.

Another radical shift in focus from *Spiral Jetty* to Arches is the change in how time *looks*. *Spiral Jetty* had been shaped by addition, not subtraction. When I saw it, I didn't think so much of the water slowly leaching and wearing away; its effect is rather that of emergence, rising, growing. It comes up out of the lake bed, encrusted and aged by durational layers of salt, crystal upon crystal, crystal upon rock. At Arches, time is measured by what is worn away. It seems more human, some-

how, related to our aging process of shrinking and becoming diminished; our skin goes slack and we undergo a constant process of erosion—hair, gums, bones, mobility, memory, flexibility. *Spiral Jetty* is a model of aging antithetical to what we know and expect. It entered its thirties in a form different from that in which it entered the world, but it now seems victorious, perhaps an emotional rather than physical analogue of aging. Weathered and wiser, its current form is the accumulation of experience. It still has a great deal to say, even though it isn't the triumphant coil of earth it once was.

"The human mind may not have evolved enough to be able to comprehend deep time," writes McPhee. Greg's night in the tent coaxing his girl to crawl into his sleeping bag doesn't even count as time in this sense, and neither do Colonel Flagg's evenings sitting by his open door or the time I spent on this trip. *Spiral Jetty* is superficial time—a few decades. The Great Salt Lake is deeper time, of course, but still not deep enough. We just can't know "deep enough." But I now really understand, at least, that the dinosaurs weren't losers.

Chapter 4 } Double Negative

Feeling rejuvenated after my digression to Moab, I was ready to resume my art pilgrimage and headed out of town on the same road—Utah 191—I had come in on. My plan was to noodle south toward the state line, then head west into Nevada for my visit to Michael Heizer's *Double Negative*, a sculptural void dug in 1969 into the side of the Mormon Mesa. More Mormons!

I was in for a meandering drive, which can't be avoided in Utah. South of I-70, the main east-west highway in the state, and east of I-15, the main north-south highway, the roads shatter into small, winding secondary routes that twist and bend their way along rivers with names like Cane and Dirty Devil. There's no quick way across the bottom of the state. As the crow flies it may not be a long trip, but you have to wend your way through the edges of national forests (Dixie, Fishlake), national monuments (Grand Staircase Escalante, Hovenweep), and state parks (Goblin Valley, Dead Horse Point, Edge of the Cedars, Coral Pink Sand Dunes), as well as long, slow stretches in the Navajo Nation and Monument Valley. Points of interest include "Recapture Pocket" and "Big Rock Candy Mountain."

I stopped at one tourist attraction, Hole n" the Rock, about fifteen miles south of Moab. Though its curious punctuation might suggest that it boasts both a hole *and* a rock, the site is actually a hole *in* a rock, excavated by its owner in the 1940s and 1950s. Albert Christensen—painter, sculptor, taxidermist—sandblasted and carved his way into the rock, eventu-

ally building a five-thousand-square-foot home for himself, his wife Gladys, her doll collection, and his taxidermy menagerie. It took him twelve years, from 1945 to 1957, to move about fifty thousand cubic feet of sandstone for their cozy lair. The result is an appealing—albeit dark—suite of rooms that stay cool during the summer and warm during the winter. Albert also found the time to carve the smiling face of FDR into the side of their home (visible in the photo, outlined in white beneath the O and C of "ROCK").

I found myself captivated by the entire venture. Walking through the dank and faintly musty rooms, I pondered the bemused complicity of a wife living with and in her husband's grand dreams. I saw that peculiar American insanity that holds that anything goes as long as you don't hurt anybody. I saw a quiet couple living far from anywhere, slowly building their cave, populating it with dolls and frozen, bucking, wild-eyed donkeys, yet still maintaining a bourgeois domestic front with guest towels and shaped soaps and, next to the seizing donkey, Albert's dresser.

I was touched by the shared passions of Albert and Gladys, the fact that these plainly named Nordic people concluded that, yes, they wanted to sandblast their home into the side of a rock and, yes, Albert needed room for his painting studio and his sculptures and his taxidermy experiments. They had afghans and throw rugs and furniture that could have come out of *Sunset* magazine. And yet, *they lived in a hole in a rock*. The whole thing is odd to its core.

Two things moved me greatly, the first being the devotion that I imagine existed between these two. Though the lifestyle options for a couple in the 1940s and 1950s weren't half of what they are today, Albert and Gladys, together, went off the grid. They chose this type of life. Perhaps she rolled her eyes; perhaps she gladly assented. But at base Gladys understood Albert's need to craft their home to such a marvelous extent. She eschewed what there was of Moab society, forgoing the socially acceptable venues of bridge clubs and church socials, to live in a manmade cave with her husband and his donkeys. And Albert knew, somehow, that Gladys would not only sup-

port but perhaps even celebrate this off-kilter life, keeping him company as the snows whipped down the canyons and he spent long hours in his studio painting pictures of Jesus. I saw in this rock a complete commitment shared by two people. How many wives would have walked away were their husbands to say, "Honey, I want to live in a rock. I want our cave in the rock to be filled with taxidermied animals. And in my spare time, I want to carve a monumental portrait bust of FDR into the side of our home"? And how many husbands have the sheer audacity, the creative genius, even to think that way?

As I wandered with the other tourists through the bathroom and kitchen, this question of creativity haunted me. That was the second thing that moved me. I found that most of the people visiting Hole n" the Rock that day approached it, as I did, with reverence. It would be very easy to coat this attraction with irony. But none of the visitors seemed to do so. Instead we were stunned that these normal-sounding people not only possessed such a vision but actually realized it.

Clearly, in Utah in the 1940s and 1950s, there was room for expansive thought and marvelous plans, for invention and improvisation. While historians speak of the conformity of postwar America, here was dripping proof that the creative urge is never dormant, never fully quashed. In the era of residential subdivisions and the gray flannel suit, here was a quiet brilliance at work, a man and a woman who devoted themselves to their own strange pursuits, unbothered and untethered. I imagined Albert painting in his studio while Gladys listened to the radio in the kitchen, making sandwiches or putting away plates in the cupboards. I imagined all the trappings of domesticity, the sheer normality of keeping a home with couches and dusting and lamps and hi-fis, constantly undermined by the sheer oddness of living in a giant rock. Domesticity triumphs; within just a few minutes of entering the Hole n" the Rock, you almost forget that you are in a cave

excavated by its seemingly ordinary occupant. You focus on the furniture, on the little appointments—the dish towels or Albert's razors—that bring your domestic life into conversation with theirs.

What drives some people who possess such urges to make the grand gesture, like Michael Heizer and his *Double Negative*, while others, like Albert and Gladys, quietly construct something just as monumental? Heizer and Christensen both moved earth for their respective projects—it was probably harder on Christensen, working with sheer rock, though Heizer moved 240,000 tons of rhyolite and sandstone. The question of why one is art and the other a touching oddity might have been definitively answered by Marcel Duchamp in the early twentieth century: "Because I said so."

Heizer would be horrified by the comparison, of course. He believes that a masterpiece is a masterpiece, while a carved rock home is just a home. Self-definition plays no part in the formulation. At the same time, though, perhaps more than any other artist of the land art movement, Heizer positions himself as an artist and as an authentic cowboy, the real deal. Profiled by Michael Kimmelman in the *New York Times* in 2005, Heizer wears a broad-brimmed cowboy hat, a sheepskin-lined denim jacket, and more wrinkles than Sam Shepherd, Tom Petty, and Tommy Lee Jones combined. It is hard to imagine, reading this profile, that Heizer, along with so many others, was busy making shaped canvases in New York studios in the 1960s. For the image he presents now is someone who came from the West, lived in the West, and *is* the West.

Heizer is the son of a Berkeley anthropologist whose grandfather, also an academic, was the lead geologist for the state of California. On the other side, Heizer is descended from a Nevada tungsten mining family. He moved around a great deal as a child and landed in New York City in 1966. In 1969, Heizer took it outside.

With financial support from Virginia Dwan, probably the most influential and generous of earth art dealers and backers, Heizer completed *Double Negative* the following year. Dwan bought the land and underwrote the work's construction, and her gallery exhibited photographs of the finished piece. *Double Negative* is one of the few works on this trip not technically connected to Dia—Dwan donated it to the Museum of Contemporary Art, Los Angeles, and it is still part of the museum's permanent collection. Shortly thereafter, Heizer started conceptualizing his most truly monumental work, *City*, which he has been building ever since. Heizer says it will be at least another decade before the work is completed.

City will eventually be one and a quarter miles long and about a quarter of a mile wide. The size is inconceivable to me; Kimmelman helps put it in perspective: "Picture a sculpture the size of the Washington Mall, nearly from the steps of the Capitol to the Washington Monument, swallowing many of the museums on either side. That's how big it is" (Kimmelman, "Artist," 34). *City* will, not surprisingly, take the shape of a city, with forms loosely drawn from ancient North American mounds, Mayan architecture, and the surrounding landscape. In pictures it appears beautiful and oddly blank, the broad geometry of the massive forms serving to highlight the play of light across the desert and the apocalyptic oxymoron of calling this uninhabited complex "city."

I would have loved to visit *City*, but the site is closed until completion, so I settled for *Double Negative*. As I drove away from Hole n" the Rock, that site's cozy eccentricity quickly slid away and was replaced by more long, monotonous, desolate stretches of driving. Other vehicles were scarce through this leg of the journey, and the muffled anxiety of being alone and ill-prepared surfaced once more. I would go for an hour without seeing another car, but this time, instead of driving in tired circles around a cattle herd, I was on a major road,

and that was somehow both more reassuring and more troubling.

I was excited, though, about driving through the Navajo Nation. In Moab I had done a little poking around, reading the Navajo Nation protocol for visitors: don't hang around in teepees, which are still used for religious purposes; don't walk around snapping pictures of people; don't—do they really have to say this?—enter people's houses without an invitation. I shudder to think of the tourists who had come trampling through the area, opening any door they passed and sticking their heads into private homes. Reading this literature gave me the sense that I would be passing through communities. Maybe there would even be a museum, or "sample pueblo," where I could learn more about this vast region.

I was disappointed to find that on my prescribed route the only real population centers were roadsides and pull-offs, where people sold silver and blankets; at most, there might be a shed for the vendors. As far as I could tell, this was the main route through the area, but tourist attractions were few

and far between. So I simply drove, conscious of a murmuring bleakness at the core of the landscape. Whether it originated in the thought of Native Americans now corralled into casino-filled corners of the landscape or the copses of lonely rock formations I kept passing, I couldn't tell. There was a solidity and timelessness in this whole area but also an emptiness, a void that left room for mythologies and worship and superstitions and thoughts designed to fill the space the landscape carved into the self. I'm far from a mystical person—my first words upon reaching the summit of Machu Picchu were "Do you think there's anything to eat up here?"—but I did feel something stir inside me while driving this stretch on a brilliantly sunny day. Though I had been more isolated while looking for the *Sun Tunnels*, I had a greater sense of isolation in the Navajo lands. The forlorn monuments standing separately, stunted against the sky, embodied a solitude and separation that I mulled over mile after mile.

My route, following U.S. 163 and 160, took me south into Arizona. Then I headed back north via state road 98 to Page, Arizona, on the fringe of the complexly crafted Lake Powell and all of its systems. I had never felt so good as a driver as I did here in northern Arizona. There were moments of unadulterated pleasure, stretches where I imagined I was in a car commercial, streaming along the edges of a giant waterway, going ninety miles an hour on a road that seemed tailor-made for German-designed autos. It ended at the Glen Canyon Dam, a work of real industrial monumentality, something I had nearly forgotten on my pilgrimage and a sight for sore eyes. I'm ashamed to say that so much organicity was wearing on me, all the curves and irregularity and erosion, despite the aforementioned *Fahrvernügen*. I craved straight lines and right angles and corners that hadn't been chipped away by rivers and time. The dam was filled with tight cables and trusses and bridges, all of which made me realize just how much I was missing the manmade.

The dam also reminded me of efficiency, something else I had left behind. I was growing frustrated with all the double-back driving the day had required and, in a moment of pique, had actually taken a pencil and straightedge to my road map to calculate how much shorter the drive *would have been* had there been a direct route from Moab to St. George, still in Utah but the largest town near *Double Negative*. This was a fruitless and juvenile exercise, but I am a person of square blocks and grids and piles lined up neatly on all available surfaces. I had tried hard, in preparing for this trip, to conquer my native impulses, starting out with a deliberately vague itinerary that ignored those involuntary yet insistent questions: *Where will I stay at night? Who will take me to the hospital? What is the plan for today?* I was pleased with my progress toward a more spontaneous attitude—despite the uncomfortable evening in Montello—but the circuitous route to St. George brought all my demons back.

Zion National Park was the last landmark before St. George, and I approached it eagerly, buoyed by a snack of elk jerky bought earlier at the side of the road. Two unpleasant

surprises awaited me in Zion. The first was the required admission fee just to drive through the park—a hefty twenty dollars when I had only ten in my wallet (having spent thirty dollars on jerky a few hours back). The second was one of the passes within the park itself—a single-lane tunnel blasted through a rock core. Hole n" the Rock had been comforting, but this hole in a rock was terrifying and claustrophobic. Rangers would block traffic off at one end to let a line of cars through, then block off the other end for cars going in the opposite direction. The cars entered the rock without warning, and by the time I realized how cramped the space was, it was far too late to turn around. A few tiny gaps in the rock wall let in knifelike shafts of light; otherwise it was pitch black. I would have preferred three more hours of circuitous driving to the torture inside that tunnel.

Traffic inched along, the rock ceiling seemingly touching the roof of the car and the walls just as close outside my windows. There was absolutely nothing visible in any direction except the taillights of the vehicle in front of me. My heart was racing and sweat was running down my back and temples. My hands slipped and shook on the steering wheel. I was hyperventilating and trying to find the air to scream. I have never experienced such enclosure or darkness; it would be impossible to find in a city, and I've yet to be anywhere at night, no matter how remote, that wasn't weakly illuminated by the moon or stars. It was like being stuck in an MRI machine with no light and no technician. This pass through the tunnel telescoped to encompass and then eclipse the hundreds of pleasurable miles I had driven that day, through terrain so radically varied in mood and spirit. Hole n" the Rock, the Navajo Nation, me and my Jetta shooting around Lake Powell—all of those small victories disappeared, replaced by the sensation of time stopping in that terrifying tunnel, an eternal eight minutes spent in the heart of darkness.

I was still shaking, dripping with sweat, and tasting elk jerky reflux in my throat when I pulled into St. George a short time later. I knew from my reading that St. George might be a likely venue for spotting sister-wives. Brigham Young had his second home here, and the town remains a Mormon stronghold. Colorado City, Arizona, was my first choice for sister-wife spotting, but at that point I was too exhausted and rattled to drive the extra forty miles, especially since it would have meant doubling back again. I checked into a motel and asked the desk clerk where the restaurants were. He pointed down the street. I walked in the direction he had pointed, passing outposts of every fast food chain ever established but finding nowhere that I could get a bourbon and a big steak. I walked back to the motel and asked again about the restaurants. "You just passed about ten of 'em!" the clerk laughed, as if I were a moron. So I ate at Wendy's, where there were no obvious sister-wives. The closest I came was a family consisting of one man and eight children, all white blond, who would have lined up perfectly as a set of dolls. The girls wore floral dresses and the boys short-sleeve dress shirts. I was going to have to settle for a spicy chicken sandwich with a Mormon clan rather than a night out among polygamists.

The next morning I headed for Overton, Nevada, a quick hop from St. George. The first building I came to was a pretty luxurious Ramada Inn. I went into the lobby to ask directions to Heizer's *Double Negative*. The sixteen-year-old girl behind the desk had no idea what I was talking about. I drove on to what seemed the largest gas station in town and asked again. "Oh sure, I mean I think I know . . .," replied the woman behind the cash register. "Well, wait . . . Mary? Mary, do you know how to get to that thing by the artist up there on Mormon Mesa?" Mary walked over carrying a package of hot dog buns. "It's pretty big, I think, so you can't miss it," she said. "If you can get up there I think you'll see it pretty easily." She

looked out to the parking lot. "That you? That black car?"

I said yes, that was my car.

"Oh, you can't do it in that. You'll need a four-wheel drive to get up there. It's pretty steep."

"It is?" I looked around outside. Nothing seemed all that steep.

"Yeah, you'll want a different car. I mean, you can try it, but if you get stuck up there there's not really much you can do."

She gave me broad directions to Mormon Mesa and told me to stop at the airport at the base of it for more details.

At the tiny airport, they had a black binder with a page of directions to *Double Negative*. They were imprecise in the way the *Spiral Jetty* directions had been. With no real landmarks on top of the mesa, it's difficult to pinpoint locations. They did include GPS coordinates, but unless my iPod could morph through the sheer force of my will into a GPS locator, those were useless. The airport attendant too looked at my car and shook his head. "We'll be right here if you need us," he said.

I took a paved road perhaps another quarter mile to a dirt road and the dirt road another mile or so to the base of the mesa. From there the quick diagonal path up to the top of the mesa looked almost impossibly steep. If it were a ski run, it would be considered a chute. I had no idea if the car could make it; I had never taken it up or down any incline more severe than what might be found, say, in a downtown parking garage. But I had to do it, right? I had to keep going. I didn't have a panic attack in that tunnel just to turn around now. I patted the dashboard, talked quietly and earnestly to the car, then backed up (ridiculously I thought it might be easier if I had a running start), closed my eyes, and punched the gas.

It was a quick, exhilarating ride characterized by lots of churning gravel, but I made it. The ground was loose and it was hard for the tires to grab onto anything, so there were a few seconds here and there where the car searched for a grip

and I started to slide backward. But I was at the top of the mesa in less than a minute, another small triumph.

Conditions on top were what I had come to expect on this trip: no real markers, an ill-defined road, and lots of rocks that seemed to be looking greedily at the undercarriage of my car. Since no other option was apparent, I started down the road. The directions said that the road cut across the top of the mesa but that there was a turnoff to the west about halfway across. The west? The west? Would that be on the right or the left? Just as at *Spiral Jetty*, I had arrived at my monument in the middle of the day, making it impossible for me to navigate the only way I knew how: by figuring out where the sun was in relation to the time and using that as my compass.

So I drove and drove some more, just keeping my car in the tracks like a kiddie car on an amusement park ride. The wheel may turn, the child may "drive," but the tires are firmly attached to a rail. Steering is an illusion. This allowed me to focus on the next question: What would the turnoff look like? A subtle break in the brush that lined the road? Would it be

marked with a big stick or a rock? A matchbook? A road sign?
I had no idea what I was looking for; I just knew that I wasn't
finding it. And before long, I hit the other end of the mesa,
nearly three miles from the edge where I had started.

How could I have missed a fifteen-hundred-foot-long, fif-
ty-foot-deep gash in the world? I drove back down the single
road slowly, peering in the harsh light at the side of the road
like Nancy Drew looking for a clue. At every possible turn-off,
I got out of the car to inspect it more closely. Was this a road?
Was that a road? I was back at the first edge of the mesa. Here,
on the lip, I had faint cell phone reception. I looked in one of
the Triple-A books for the area code for Overton, then called
information for the number of the airport. I hoped someone
there would be able to give me a tip, tell me what I was look-
ing for, but there was no answer. Though thrilled that my
car and I had made it to the top of the mesa, I didn't want to
tempt fate by sliding down the incline, checking in at the air-
port for the mere promise of more information, then trying
the ascent a second time.

So I started back across the mesa for the third time, at a
crawl. More than halfway across I decided to take what looked
like my best shot. I pulled off into what seemed the largest gap
between two scrub bushes and parked the car. There were a
lot of little bushes underfoot, and I wondered whether the un-
dercarriage of the car, which had been running all day, might
be hot enough to start a fire. I wasn't sure if this could actually
happen, but the thought alone made me get back in the car
and move it to the barest ground I could find. Still worrying,
I checked the landscape and realized that, should I see a faint
plume of smoke from wherever I happened to be, I would not
have time to halt the nascent inferno, and my burned-out Jet-
ta would forever be marked as the car—and I as the dumbass
driver—that destroyed Mormon Mesa. My poor car would
share the fate of the rusted-out amphibious vehicle and old

Dodge truck near *Spiral Jetty*. The thought was too much to bear, so I moved the car again, took a liter bottle of water and poured it over the ground, then put the car back over the wet spot. What more could I do? Having learned by now that Balance Bars wouldn't last five minutes in the heat, I stuck a banana and another bottle of water in my bag, locked the car, promised the baking laptop I would be back before too long, and headed on foot down the dusty path.

I had no real idea where I was going, but I still held out hope that *Double Negative* would be hard to miss. I trudged along the path, constantly looking back at the car until I lost it in a heat shimmer. Now I felt truly alone. Bugs buzzed around my head and flies landed on my shoulders. I started to worry that I wouldn't be able to find my way back to the car—one more source of anxiety. But I kept walking and tried to establish landmarks for myself. I ate the banana and draped strips of the peel over little bushes. After I had left about three strips, though, a bird flew in and took one of them. So much for my survivalist instinct.

I walked for what seemed like hours through the utterly flat terrain. My neck was getting sunburned, and my running shoes were turning into sponges, trying to soak up the sweat from my feet. The walk probably lasted only half an hour, but at noon in the Nevada summer, the minutes stretched like taffy. I still couldn't see any gouges in the mesa, nothing that looked remotely like a monumental work of art. Then faintly, on the horizon, I spotted a shiny blob. It could be a mirage, I thought to myself, as if thirty minutes in the desert had rendered me a member of the French foreign legion crawling across the Sahara in search of water. I kept walking toward it and watched as it was transformed from a shiny blob to a dark suv.

Now I faced a new dilemma. Clearly there was someone else out here. But would they be friend or foe? I pictured a

bunch of sixteen-year-old guys sitting on their tailgate, listening to ZZ Top, shooting their rifles at empty beer cans scattered atop the mesa. I imagined what I would look like sauntering up to them out of nowhere. "Hey guys, how's it going?"

I stopped walking and crouched down to think it over. I was about two miles from the edge of the mesa and three miles from the airport. I imagined my broken, violated body baking there on the top of the mesa. Snippets of *Deliverance* alternated with *The Accused* in my head. I debated going back to the car. Was that cowardly or prudent? Where, once again, was the line between legitimate concern and paranoia?

I continued on, creeping forward in a crablike shuffle. Because the landscape was so flat, I would be easy to spot if I stood up, and the little bushes offered no cover whatsoever. So I tried to get closer to the SUV from the side. I couldn't hear anything from the vehicle, no ZZ Top, no National Public Radio, no hint of conversation. I kept low to the ground, like a soldier, even though my quadriceps were screaming. When I was about a hundred feet from the SUV, I heard a man's voice. I started crabwalk-racing in the other direction, trying to escape before my captors saw me.

I heard someone open the trunk of the SUV. Clearly they were close enough to see me. My heart was racing but I turned back to look instead of breaking into a run. It was a woman who raised her arm in greeting. "Erin?!" It was Heather. And Bill. My fellow pilgrims.

Here they were, a week after I had left them to cavort in the *Spiral Jetty* sunset. The coincidence was unbelievable to me, less so to Heather, and even less so to Bill, who seemed completely unperturbed by my presence. "We're kindred spirits," she said to me. "It doesn't surprise me at all. We're out here in the world, looking for the same things."

I was relieved not only that I wasn't going to be gang-raped

on Mormon Mesa, but also that they had marked *Double Negative* for me. I realized, there on its edge, how difficult it would have been to find on my own, by car or on foot. Even from a foot away, *Double Negative* is camouflaged, as only a void can be. It is visible as a hole in the earth, and nothing more. A non-alert driver could motor right into it, tipping a ton of steel off the edge into its bed. Fully worked into the landscape, it is a seam where the solidity of the mesa is temporarily riven, like a gap in perception or in the figure-ground relationships we automatically construct to track our place in the world.

The work itself is a pair of notches blasted into the ground, facing each other across a natural break in the perimeter of the mesa. Below, a long, slow, crumbling descent leads to the desert floor, a plain of scrubby brush bisected by a verdant arc that marks the course of the Virgin River. The two halves of the sculpture—one to the south, one to the north—mirror each other. When you stand at the edge of one notch, you're staring directly into the other. From inside one notch, the other appears miles away, but in fact the two halves of the

work are connected by a fairly quick walk along the top of the mesa. Thus *Double Negative* consists not only of the voids that have been dug into the land but also the connecting bridge of space between them.

The view from the lips of *Double Negative* is stunning. Sky eclipses the land; there's nothing above you but color, no mountaintops or trees to break up the sense of sheer space. Across the mesa the land appears flat, undifferentiated, and endless. Distant hills bound the view, hazy, slow, and solid. The isolation is tempered by the promise of the green valley below, which sets off the dun color of everything else and evokes associations with civilization, agriculture, fecundity, and mastery.

Double Negative works by accentuating the surrounding positives of land and, oddly, sky, which the void makes palpable as its own volume, turning this dimensionless element of air and light into something as three-dimensional as the land it meets. Standing at the top of *Double Negative*, even before entering it, I understood exactly what Heizer had meant

when he said, "I think size is the most unused quotient in the sculptor's repertoire because it requires lots of commitment and time. To me it's the best tool. With size you get space and atmosphere: atmosphere becomes volume. You stand in the shape, in the zone" (Kimmelman, *Masterpiece*, 204–5).

If, as I claimed in the first chapter, *Spiral Jetty* works as both a perfect form in isolation and as a personal, durational experience—proving Michael Fried's ideas about presence both right and wrong at the same time—*Double Negative* functions mostly as the latter. It requires the viewer to make sense of it ("You stand in the shape, in the zone"); without a viewer it mimics nature, the same process of subtraction that shaped the landscape around Moab, almost too closely to be art. Here it wasn't Fried's theory that echoed in my head. Instead, I was struck by what might seem a strange parallel: *Double Negative* and New York school painting.

Heizer was of the generation of artists who turned their backs on the New York gallery scene in the 1960s, when abstract expressionism and pop art had run their courses, ceding way to minimalism and conceptual art. Like fellow land artists Robert Smithson and Walter De Maria, from whom the Nevadan has otherwise worked hard to distance himself, Heizer found this insular world too limiting and too small for his grand visions. It made sense, given his background, that Heizer would exile himself quite happily to the land of his mining ancestors. This is not to say, though, that Heizer's work—or the work of "land artists" in general—represents the great break often ascribed to it. It participates directly in the urge to sublimity and its relation to size and scale, an engagement that is also evident in much of the work of the abstract expressionists. I sweated over *Double Negative*, asking of it the same questions that I had asked of the paintings of Jackson Pollock, Mark Rothko, and Barnett Newman.

The American sublime has paradoxically resided in both

the East and the West—I'm thinking here of the work of the Hudson River School and Albert Bierstadt and Ansel Adams, the granddaddies of the American sublime—and perhaps it was the sense of an exhausted tradition in painting that drove at least two abstract expressionists to ruin, Rothko by his own hand and Pollock by his own bottle. There is an ultimately lonely and searching quality in much of Pollock's monumental work, best seen in the forlorn handprints that mark the top edge of *Number 1A, 1948*, a painting that is nearly six by nine feet. "I tried," the dwarfed handprints seem to suggest. "Please don't forget I was here."

Pollock's generation of American painters were working with huge canvases reminiscent of the grand history paintings of the eighteenth and nineteenth centuries. Easel painting was over, and size mattered. Heizer was one of the artists who carried the torch of size off the island of Manhattan and into the West, much as his artistic ancestors did when they packed up their easels and went to the Grand Canyon.

Heizer's comments about his work have eerie echoes in those of Mark Rothko, of all people, the cowboy meeting the suicidally cerebral. Heizer has said, "It is interesting to build a sculpture that attempts to create an atmosphere of awe. Small works are said to do this but it is not my experience. Immense, architecturally sized sculpture creates both the object and the atmosphere" (in Brown, 33). In his aspirations to the sublime, to the "atmosphere of awe," Heizer uses as his benchmark the human form. He is conscious of the place of the viewer—"in the shape, in the zone"—and aspires to an encompassing experience in which the traditional separation between object and viewer is abandoned. This is a project far different from Smithson's. Fried's concern was with the sharing of space between object and viewer. In Heizer's work, space isn't shared. Heizer's viewer can't pull himself apart from the object; it envelops and surrounds him; he exists in the very space it creates.

Decades earlier Rothko was toying with the same ideas. While not explicitly declaring size the "best tool," he came close when he commented in a symposium, "I paint very large pictures. I realize that historically the function of painting large pictures is something very grandiose and pompous. The reason I paint them, however—I think it applies to other painters I know—is precisely because I want to be very intimate and human. To paint a small picture is to place yourself outside your experience, to look upon experience as a stereopticon view or with a reducing glass. However you paint the larger picture, you are in it. It isn't something you command" (quoted in Breslin, 280).

Rothko soft-pedaled his goals by claiming he was aiming at "intimacy" and distancing himself from the "grandiose and pompous," but the effect is actually the same. Both Rothko and Heizer were moving in the direction of inclusion, of drawing the viewer into a deeper dialogue with the object. For Rothko the underlying sentiment was intimacy, for Heizer, transcendence. But both saw the scale of the human body as foundational.

The comparison forces one to ask how the human form could be a vehicle for both the sublime and the intimate, two sensations that are pretty radically opposed. You could argue that intimacy is necessary for experiencing the sublime; sublimity depends in part on one's utterly minimal presence in the face of something grand, and recognizing that paltry presence demands a certain intimacy. The sublime forces one to confront one's meek existence, one's puny proton. Acknowledging one depends on recognizing the other. You have to be small to know big.

At *Double Negative*, one seesaws between these poles, between sublimity and intimacy, big and small. From the outside, the mesa and the valley spread out before you. You're at the mercy of the sun and the wind, and if you fell off the

mesa, no one—except Heather and Bill—would know. Inside *Double Negative*, though, the experience is very different. The earth is cool and the notch deep. The unrelenting sun takes shape here, and you can track the progress of the day by the movement of the shadows along the sides. The interiors are large but not vast, easily accessible and navigable. If you don't look out toward the other notch, you feel contained and enclosed in the best sort of way—not claustrophobically or oppressively, but safely and almost sweetly. I haven't read many references to *Double Negative* as a womb, perhaps because it is open to the sky and the edge of the mesa, but the contrast between the wide-open exterior and the enclosed interior engenders a sense of comfort, a *vagina dirtata* that envelops rather than threatens.

The scale thus shifts wildly between inside and outside. Outside you are a microbe, a nothing, an ant in the desert hoping not to be squashed by the sky. A quick clamber down into a notch completely eliminates this vastness and replaces it with a spatial realm more like that in which most of us operate on a daily basis, the realm of the room, the slice of urban park, the backyard. Outside, global; inside, local. I kept exiting and entering the notches as quickly as I could, marveling at the effects achieved with just a few steps. Here Heizer's transcendence meets Rothko's intimacy on a human scale.

"Be careful!" Bill called over to me. I had been running up and sliding down the edges like a child. He had been setting up his camera on a tripod and moving it, inch by inch, to create a series of pictures that would ultimately form a sort of tessellated panorama. "I'm fine!" I said. Heather was over at the other notch. "I know you're fine," he called back. "Just don't make it erode faster than it already is."

I stopped. I hadn't thought about that. Pictures of *Double Negative* from early in its life show clean cuts and straight edges, almost as if the mesa had been sliced with a cake knife.

Now the interior walls are knobby and flaking, the floor of each notch overlaid with rocks, sand, and dirt. My shoes sank deep into this unstable mixture. Unlike Smithson, who saw the decay of *Spiral Jetty* as inevitable and even desirable, Heizer is troubled by the deterioration of *Double Negative*. He told Kimmelman that he wants to "recover" the work, to eternalize his initially clean cuts and straight edges using a concrete mixture. "It will have too short a career if it disappears," he has said (Kimmelman, "Heizer"). And indeed, Heizer's *City* is projected to have a permanence utterly foreign to what we know as earth art. Instead of softening over time, *City* will, if all goes as planned, remain as straightedged and solid as the Mayan monuments on which it is loosely based.

This would seem to be a serious rift in the small group of artists known for this sort of work. For Smithson, the work has been made increasingly "whole" by natural processes, by the water that has advanced and retreated, covered it with salt, and washed away soil. For Heizer, natural forces (and art tourists like me, of whom he speaks with contempt) degrade his work. He is intent on his earthworks' having a long life, oddly so given the unforgiving landscapes in which they are created. For Smithson, decay and erosion represent the fourth dimension of art: the passage of time. For Heizer, decay and erosion take art away from the deep light and time of transcendence and into the realm of the merely mortal.

This distinction places Heizer in a somewhat conservative category, those who believe in the fundamental and eternal essence of great art. These are the artists who believe in the masterpiece, the grand gesture that lasts through eras and civilizations. From Chichén Itzá to the ceiling of the Sistine Chapel, art alone endures. One would think that those as connected to the land as Heizer would accept that time ultimately does its work on all things, but instead he fights it. He thinks of redoing *Double Negative* in a more permanent form; he has

spent decades building a monument designed to withstand all the elements, simply to persist through the centuries.

I am drawn again to parallels with the New York school painters. Barnett Newman, master of the "zip," mused on the issue of time a great deal. He wrote most famously on the topic after seeing the ancient Indian burial mounds in Ohio in the late 1940s. This trip represented a turning point in his thinking about art, one that he would return to again and again in his prolific writings. The notes in which these ideas first appeared are now known as "Ohio, 1949" but they were never published as a self-contained essay. Rather, Newman grouped them under the far more ambitious title "Prologue for a New Aesthetic" (in his collected writings, edited by John O'Neill).

Newman's experience at the mounds brought about the same sensations that his compatriot Rothko and his successor Heizer were striving for (O'Neill identifies it as "a staggering epiphany of self against undefined space"). Newman wrote that he finally saw "the self-evident nature of the artistic act, its utter simplicity. There are no subjects—nothing that can be shown in a museum or even photographed; [it is] a work of art that cannot even be seen, so it is something that must be experienced there on the spot" (174). The mounds were encompassing and enveloping: "somehow one is looking out as if [from] inside a picture rather than outside contemplating any specific nature" (175). Like Rothko and his "stereopticon view," Newman was seeking a new kind of experience, an alternative to that offered by the easel picture.

Both Rothko and Heizer tried to achieve this transcendent experience by identifying the human scale—whether in two dimensions or three—and encompassing it. Newman took an entirely different tack. In "Ohio, 1949," he wrote:

> Suddenly one realizes that the sensation is not one of space or an object in space. It has nothing to do with space and its ma-

nipulations. . . . The sensation is the sensation of time—and all other multiple feelings vanish like the outside landscape. . . . Only time can be felt in private. Space is common property. Only time is personal, a private experience. . . . Each person must feel it for himself. . . . The concern with space bores me. I insist on my experiences of sensations in time—not the *sense* of time but the physical *sensation* of time. (175)

Time proved to me to be the essence of *Spiral Jetty*. It was Smithson's intent; it was my experience of the work. Time is proving to be *Double Negative*'s undoing, much to the artist's dismay. But Newman's formulation of time unites the simultaneous intimacy and sublimity of *Double Negative*. In attempting to defy the passage of time, Heizer aims at timelessness. It is perhaps not the enduring aura of the masterpiece that he seeks but the sensation of time that Newman describes. For Newman art was a vehicle for this sense of private time, this ultimately personal experience that would lead one to the eternal *sensation* of time. This sensation can only be achieved through an individual's own awareness.* Similarly for Heizer, the sense of sublimity can be achieved only through a solitary experience.

The artists that *Double Negative* called into my head all struggled to achieve a new type of experience that they variously described as transcendent, religious, or awesome. Ultimately they all aimed at creating something that would take viewers out of their own experience and into a different realm. It is this hope, this folly, that brings Heizer full circle, back to the artists and scene he rejected. He moved to Nevada, he dug holes in the earth, but he still wanted works that would endure despite putting them in a realm that was destined to destroy them.

* We're back to Michael Fried here, who concluded "Art and Objecthood" with the sentence "Presentness is grace" (Fried, 168). Suggesting that *presence* is theatrical and staged, he offers *presentness* as the noble alternative.

"I don't work with scale," Heizer has said. "I work with size. Scale is an effete art term" (Kimmelman, "Heizer"). Size is what is possible out in Nevada, or Utah or New Mexico. Scale is what one plays with at the easel. Size is definite, measurable; scale is relative. Yet he has also spoken of returning to painting, according to Kimmelman, perhaps to try and translate the lessons of size into the question of scale. It is almost as if Heizer had to push through size to get back to scale. It may be no surprise, then, that his works can productively walk this tightrope; *Double Negative* can be both vast and human, sublime and intimate, timeless and subject to erosion.

For Heizer and Rothko, this perspective, this relational encounter, has hinged on space. For Newman, veering between the personal and the eternal, it hinged on time. Deep time is somehow, for Newman, personal time. Time is private; space is collective. All three artists, though, were aiming at the same target: How does one construct, through art, an experience different from everyday life? It seems to me to be a fundamentally different question than that asked by Smithson—who might instead have asked, How does one construct an experience different from everyday art?

The similar aim of Heizer, Rothko, and Newman makes odd bedfellows out of the three of them. But I'm here, after all, to make odd bedfellows. I had expected to drive out to *Double Negative* and experience the monumental West; instead I could not stop comparing my experience of the work with my response to other works, and I could not stop comparing what Heizer said he was doing with what these other American artists in another seminal moment said they were doing. If Duchamp cracked open the question of what art is (it is what we say it is), then perhaps New York school painters were trying to crack open the question of what art does in the realm of experience rather than form. Recoiling from the braininess of the cubists, the excesses of the fauves, the

dim psychological diagnoses of the German expressionists and the surrealists, American artists of the 1940s and 1950s looked back even further, to the papal commissions and royal decorations designed to inspire awe rather than analysis. This is Heizer's legacy, I think, more than any connection to the other earth artists—which indeed he disavows.

I spent the afternoon at *Double Negative*, leaving Heather and Bill again as the sun began to set. We talked and then left each other alone, or as alone as we could be given the circumstances. Just as when I left *Spiral Jetty*, they asked if I needed anything, if I wanted to be followed back, if I had enough water. I felt as if they were my guardian angels. I didn't even ask where they were headed next; I wanted to retain the air of serendipity that had characterized our meetings so far. I walked in the waning light back to my baked Jetta, again able to tell east from west. You could have fried an egg on my computer. I was completely sunburned. I cranked the air conditioning, drove slowly back to the edge of the mesa, and slid down the steep chute to the dirt road that led to the airport.

My next stop was in northern Arizona. I made my way back to I-15 with the goal of getting on U.S. 93 South. Massive highway construction put me on a detour around Las Vegas. I sped right by. Vegas seems overpowering and frenetic from the inside but a mere speck from the outside, a lonely outpost surrounded by miles of nothing. The black pyramid of the Luxor hotel was a blurry dot from the highway.

Chapter 5 } Roden Crater

I had passed Las Vegas like the mirage that it is and cut over into northern Arizona. Another two hundred miles passed. Then all at once, the desert seemed to disappear. Somehow I wasn't in the West anymore. I was in Flagstaff, the city closest to James Turrell's *Roden Crater*.

After a week spent wrestling with the heat and moisturizing my sunburned arms and neck into a slippery goo every night, Flagstaff—at seven thousand feet—was paradise. The cool air was a balm, the light gentle. I inhaled not dust but the rich, syrupy smell of pines; it seemed civilized and inviting, a threat to neither me nor my car. The desert had been hard on my little Jetta. It had been left for hours on top of mesas and next to rusted-out amphibious vehicles. It had ingested more dirt in a week than it had in six years of city driving. Now, when I turned on the air conditioning, dust blew through the vents for twenty seconds, settling on my skin and in my hair. Desert dust had even found its way into the glove compartment. I was coated with grit, and so was the car.

Like Moab, Flagstaff bordered on the precious. The entire downtown area, about eight square blocks of three-story buildings, had recently been "revitalized" and was filled with coffee houses and outdoor-gear stores. The sidewalks were wide, the parking spaces and lots generous. It was refreshing and clean and shady and surrounded by pine forests.

I don't know what I was doing there. The original plan was to visit *Roden Crater*, another site loosely characterized as earth

art. Turrell, known as an "artist of light" (not, by any means, to be confused with "painter of light" Thomas Kinkade), began crafting the crater in the mid-1970s. He purchased a volcanic cinder cone in the Painted Desert northeast of Flagstaff with grants from the Guggenheim and Dia foundations, along with other support. The plan was to create a work inside the crater that, like *Double Negative*, would be both object and atmosphere. The ultimate goal is to transform visitors by means of a heightened and theatricalized sense of light and space possible only in such a controlled area.

Everything I knew about *Roden Crater* came from what I'd read, the most complete descriptions having been written by Kimmelman and Calvin Tomkins. Turrell's ambition is, again, monumental. He has spent decades and millions of dollars constructing a celestial theater that is its own environment, complete with sound and sculptural elements. There are tunnels and chambers and portals; monolithic entrance spaces; plinths on which to recline; a fully equipped guest lodge for which Turrell designed even the furniture. Every inch of this volcanic crater has been shaped for a highly specific experience. So far, the work has taken thirty years, and the *Crater* is still unfinished. Even its Web site is still under construction.

Having heard that it is possible to contact Turrell and see the work in progress, I had corresponded with his gallery before making my pilgrimage. No luck. Turrell was traveling in Europe. Then he was unavailable. It wasn't looking good. I tried the cell phone number of a friend of a friend of a friend who at one point worked for Turrell. The number was no longer in service. I tried contacting the project office in Flagstaff directly and left multiple messages with no response.

I had read enough about *Roden Crater* to know that I couldn't just drive around and find it. The Web was littered with accounts of pilgrims much better equipped than me, with GPS locators and four-wheel-drive vehicles, who had

been forced to abandon their quests. I was under no illusion that I could find the elusive crater. Hell, I couldn't even find the *Sun Tunnels* with two sets of directions.

Yet I wanted to go to Flagstaff anyway, partly out of curiosity, partly because of my completion complex, and partly because I somehow believed I would miraculously find my way in. I had the address of the *Roden Crater* office in the downtown Federal Building and thought I would start there. I found the building easily enough, but the front door was locked and I couldn't even get into the foyers that house the buzzers for the individual offices. So I made camp in a coffee house across the street, which could have been in Portland, Northampton, or Austin. The same yoga flyers, the same indie music, the same pierced dudes working the counter. It was a wireless spot, so I brushed up on my *Roden Crater* history and googled pictures of Turrell. I wanted to recognize him should he saunter in and order a latte.

He didn't, of course, and the morning dragged on into afternoon. My muffin became a sandwich. I was tired of

waiting for fate to intervene, so I decided to drive out to the crater field, which is also a national park. Turrell had chosen his site because of its relationship not just to the surrounding land but, crucially, to the sky and celestial movement. He planned to rework the interior of the cone, regularizing it into a bowl with a completely even rim, almost like a satellite dish. Smoothing out nature's edges, Turrell would build a sort of inverted planetarium. Within the crater, he is shaping a number of interior caves; at different times of day and night, as light traverses the crater, ethereal yet sculptural forms will appear and disappear around the perimeter. The interior of the crater will thus be responsive to atmospheric conditions at every moment.

Turrell's approach is scientific and rigorous, and it echoes the temporal specificity of the *Sun Tunnels*. At *Roden Crater* visitors will "re-see" the sky, the sun, the constellations, and cloud movements on a minute-by-minute basis, but only once every 18.61 years can one experience the effects of the moon in direct alignment with one of its central tunnels.

"Turell is a sculptor of ambient space," writes Kimmelman. "Roden is about the relationship of the tunnels and rooms to the sun, stars, and land. It's about the hours you spend silently looking, and about light or the absence of it when the sun goes down" (Kimmelman, *Masterpiece*, 184). Tomkins quotes Turrell:

The idea that we do a large part of forming our reality—that's something people are not too aware of. We actually give the sky its color as well as its shape. . . . I can change the color of the sky by changing the context of vision—it's the same effect as those perceptual tests where they show you a blue spot on a green field, and the same blue spot on a red field, and you see the spots as different colors. It's what's behind the eye that forms this reality we create. . . . We like to think that this is the rational world we're

receiving through our senses, but that isn't the way it works. We form our reality. All of the work I do is gentle reminders of how we do that. (Tomkins, "Flying," 65–66)

The cost of *Roden Crater* is expected to top out at twenty million dollars when it is complete. It has already almost bankrupted Turrell more than once. If you add that to the millions of dollars needed to purchase the land and build and maintain all the other projects I had seen and would see on this trip, I would guess that the total cost of the art on my pilgrimage is close to fifty million. I don't want to, and won't, whine about all the other things the money could have been used for; people can spend money however it suits them as far as I'm concerned. But I did wonder if the effect justifies the expense. Who will be transformed by these projects? Who will benefit from these pilgrimages, and how profound could that benefit be? Would it possibly be worth fifty million dollars? Would *Roden Crater* offer a radically different experience than one could have, say, attentively camping?

Everything I had seen so far bordered on the preposterous. I understood better now why few people in Montello had seen the *Sun Tunnels* and why I had to ask several people in Overton for directions to *Double Negative* before finding even one who had heard of it. This difficulty finding locals who knew of or had anything positive to say about these monuments reinforced my preconceptions about the West. To people living in Nevada or Utah the sorts of experiences these artworks offered simply weren't necessary. Would *Roden Crater*—or anything else on this trip—matter at all if people hadn't gotten so far out of the habit of watching the night sky or waking to see the sunrise? I had assumed that what Kimmelman calls "heightened perception" was the natural state of being for those who live and work in the West, just as I imagine a ranch hand can sniff the air and say, "Smells like snow."

Are these works, then, designed to connect urbanites with the larger world they occupy but (and here I am typical) have neglected? Who are these earthworks really for?

The elevation of Sunset Crater National Park, the home of *Roden Crater*, is lower than Flagstaff's, the ground a blanket of pine, brush, and lava. Low-rising craters bubble up as far as the eye can see. Landmarks around *Roden Crater* are measured in thousands and millions of years; it's on the Moab clock. Turrell described to Tomkins a bit of the history of his crater; he dates the second, red phase of the red-black volcano to 389,000 years ago. As at Arches, throughout the crater field you get a sense of the extraordinary passage of time. You can chart the course of the lava flows and see where they almost collide with the modern asphalt—a shattering juxtaposition that reminded me of McPhee's warning that our brains are simply not yet evolved enough to understand deep time.

I went into the visitors center and asked a few rangers about *Roden Crater*. "Good luck," one of them said. "It's all private property out there, and a lot of people have guns."

"You're kidding me. I would get shot for just driving around out there?"

"I wouldn't risk it," a solemn Navajo park ranger advised.

I wouldn't have known where to go anyway. So I drove around aimlessly, trying to get a feel for the area and trying to figure out why someone would spend twenty million dollars on an inaccessible amphitheater and lodge just to demonstrate to me that my reality is continually constructed and not necessarily built on pure sensory perception. I learned that for the cover price of a *New Yorker* and confirm it every time my colleagues and I cannot even agree on what was decided in a meeting.

It was late afternoon and time to find a place to bed down for the night. Because I had been intoxicated all day by the clean, piney air, I decided to try camping once more. I hauled

out my Triple-A books and found a sanctioned campsite on the old Route 66. I thought this would be fitting, given my new status as a great American road-tripper.

It was almost dark when I pulled into my spot, but the dimming light did nothing to obscure the depressing atmosphere of the campground. A few lonely RVs were parked in its center, with spots around the edges of the lot reserved for cars. I was the only car. I found a place equidistant between the RVs and the bathrooms and struggled to put up my tent in the dark, reveling in the utility of my headlamp.

The tent erected, I drove down the road a mile or so to a diner with very few patrons in it. Luckily they served alcohol, so I ordered a vodka tonic. The young waitress returned with my drink, apologizing that they didn't have any tonic. I held up the clear glass, brimming with carbonation, and said, "It looks like you found some tonic." She explained that it was Diet 7-Up but that it would probably taste about the same. I didn't want to insult her, so I choked it down with my "homestyle" dinner and slice of pie.

By the time I returned to my car, the temperature had dropped into the forties and I was having second thoughts about camping. But the air still felt so refreshing that I couldn't imagine checking into a musty motel room. So I returned to the campground, washed up in one of the clean communal bathrooms, and crawled into my sleeping bag with a paperback. It was so cold I could see my breath, and I woke up periodically because the tip of my nose felt icy. I didn't wake up in any disoriented panic, though. I knew exactly where I was and why I was there. Perhaps I really was learning how to be alone and to adapt to new environments.

After my shower the next morning I turned on my computer to take some notes and discovered that the campsite had free wireless Internet access. Connected at last! I read celebrity gossip, checked my work e-mail account, and sent

pictures and notes to a few friends. Those notes are still in my "sent mail" folder. One of them, written in the form of an old-time telegram, read, "ROAD TRIP FINE. STOP. ART OK. STOP. LOOKS LIKE THE SLIDES. FULL STOP."

Chapter 6 } Lightning Field

A simple description of Walter De Maria's *Lightning Field* sounds perilously close to a boondoggle. Four hundred stainless steel poles poked into a nearly flat plain. Friends who had made this western pilgrimage, though, all spoke about this work with real reverence. I had spent a few days at a friend's in Tucson and was now racing north through New Mexico, late to pick up Todd, my friend and traveling companion from here on. I kept an eye on the speedometer and wondered what could made *Lightning Field* so marvelous.

While I considered the trip so far a success, I realized that I pinned this assessment on my newfound ability to travel alone without having a nervous breakdown and not on the experience of viewing earth art. The key to being alone, I had come to realize, was to have thoughts other than *Jesus, I am really alone out here.* While this may sound simple, it was a revelation to me. While I certainly hadn't managed to free myself of anxiety—getting lost, cougars, mechanical failures—I had come to enjoy the liberating feeling of solitude that had so far eluded me. The "Howard Johnson moments" had disappeared; I no longer set out on the road with trepidation. I felt unbound out in the world, so far from everyone and everything I knew. The life of a drifter—minus the poor hygiene—was beginning to appeal to me. However, as an astrologer once told me, "You are not that kind of person." He is right, but at least I had become the kind of person who could fully enjoy a trip like this.

So while I had achieved this goal—conquering my fear of solitude—I hadn't really had the epiphanic encounters with art I was hoping for. Nothing I had seen could quite be characterized as mind-blowing, and in this I was a little disappointed. My mind had been awakened, surely, shaking all that vestigial art history back into the forefront of my brain, and I was engaged, but I was beginning to recognize that I was looking for an experience that hadn't materialized.

The most exciting thing I learned preparing for this visit to the *Lightning Field* wasn't about the work itself, but about its creator, Walter De Maria. He was a drummer for the Velvet Underground. An artist who managed to be involved with painting *and* Happenings *and* the seminal "Primary Structures" exhibition of 1966 at the Jewish Museum, De Maria seemed to have tried everything. He was a composer, a sculptor, and *a drummer for the Velvet Underground! Lightning Field* is considered his masterpiece, but, my expectations diminished, I was more excited about his percussion career than anything else.

Todd's arrival at the Albuquerque airport would mark the end of my solo journey, and I was ready for the company. I figured that if I wasn't going to experience anything aesthetically revolutionary, I might at least have someone to joke around with. On my drive I had missed a crucial cutoff so I had to go east and then north rather than taking a diagonal—a mistake that set me back about two hours. I drove and drove as dusk and then night settled in. New Mexico is a poor state, with apparently no budget for highway lights, and the drive was a black vacuum punctuated by even deeper shadows, like a living Ad Reinhardt painting. I drove the whole distance alertly but had no idea what the New Mexican landscape looked like. It was simply nothing, a black nothing to complement the white nothing of the salt flats. When I saw it in daylight, over the course of the next several days, I was surprised by

how lovely the state was—mountainous, variously textured, strikingly desolate.

Lightning Field was the only real appointment of the trip. Unlike *Spiral Jetty*, the elusive *Sun Tunnels*, and *Double Negative*, you can't just show up. You must make reservations months in advance, then arrive at its "base camp" in Quemado, New Mexico, by 2:30 PM on the day of your stay. From Quemado the site's caretaker loads you into his vehicle and drives you and a handful of strangers to a cabin in the middle of nowhere, at the edge of the work itself, where you stay for a minimum of twenty-four hours. It costs about $110 a night, by far the most I had paid for a place to sleep on this trip.

Todd and I stayed the night in Albuquerque and headed for Quemado the next morning. My lack of timing and direction, already apparent the day before, reappeared, and all of a sudden it seemed possible that we would miss the 2:30 deadline. Quemado is a straight shot off route 60, which is in turn directly off I-25. It looks like quick work on the map, but is maddeningly slow from the front seat of the car. Highways that look major on maps can turn out to be curving two-lane roads clogged with slow, overburdened pickups and even slower RVs. After three frustrating hours, we pulled into Quemado with moments to spare.

Quemado's main street is less than half a mile long, and it skirts the boundary between forlorn and quaint. We saw few people and a smattering of general stores and run-down gas stations. The Dia Foundation, which maintains *Lightning Field*, has an office in town, a two-story adobe building furnished with a chair and a table. While we waited for our escort, Robert, to take us out to the site, we met our fellow travelers.

The cabin at *Lightning Field* sleeps six people in three rooms (one with a queen-size bed, the others with two twin beds each), so smaller parties, like Todd and me, wind up spend-

ing twenty-four hours with complete strangers. One would like to think this opens the door to real romantic possibilities ("Grandpa and I met at the *Lightning Field*"), but Todd and I had to accept that three women in their sixties would be our companions and there would be no opportunity for art booty. Two of the women, Ruth and Miriam, were New Yorkers, who had come west to visit their friend, Elena, a Lithuanian-born sculptor who, after working for decades in Manhattan, had picked up and moved to New Mexico to pursue her exploration of "tensile structures."

"I didn't know a soul," Elena said later about moving to New Mexico. "I just put a note on the Internet saying, 'Artist from New York looking for boulders away from city to build experimental structures,' and that was it. People started responding. The first place I saw, I took. No regrets." Todd and I were already a little afraid of her.

The caretaker, Robert, arrived at the Dia office, checked us in, and then helped load an inordinate amount of luggage for twenty-four hours into a huge SUV. He is, in many ways, your typical cowboy. Lean, taciturn, windblown, and completely bemused by the people who travel thousands of miles to see poles in the desert. Robert was part of the original crew who built the *Lightning Field*. He was still in high school in 1977, when De Maria had hired him to help install the poles. Three decades later, Robert is a living link to the work's origins. He lives "nearby"—a relative term—with his wife and some cattle. His wife prepares the evening meals that are left in the cabin for the art pilgrims and washes the linens between visits. Robert maintains the cabin, escorts visitors to and from the site, and keeps watch over the work, replacing poles when they are hit by lightning and keeping errant cattle out of the field itself.

We made uncomfortable small talk on the ride to the site, via more dirt roads and locked gates. I could not have retraced

our route for anything; it was almost like being kidnapped and blindfolded. Naturally, we speculated as to whether we'd get any lightning; Robert chuckled to himself, knowing, as we did not, that lightning is quite rare at the *Lightning Field*. We offered each other a little personal history, forging that quick and false intimacy of the plane ride, the stuck elevator, the bus caught in traffic. I sat quietly most of the time because, for the first time in nearly two weeks, I was a passenger rather than the driver, and the motion was making me a bit nauseous. I really didn't want to kick off the visit by vomiting in my lap or down the side of the car.

Todd and I were pretty excited, but our fellow pilgrims were nearly giddy. Every time we topped a rise, they would see a spot on the horizon and say, "That's it! That's the cabin, isn't it? That's it!" Robert just kept saying no, that's not it. When we finally did arrive, we all fell silent. We saw a squat and solid cabin with its own rough-hewn aesthetic appeal . . . and some poles that looked like straight pins against the sky. Far from magisterial, vast, or awesome, the *Lightning Field* was scarcely visible.

Described by Dia as "situated in a remote area of the high desert of southwestern New Mexico," the cabin and the *Lightning Field* sit in a sort of giant bowl ringed by mountains. The mountains, while distant, give the area a loose boundary, leading to the feeling that one is in a contained space. Like *Spiral Jetty*, the *Lightning Field* is in an area bounded by the mountains, which are in an area bounded by sky. There are no other structures visible from any spot on the property, though one of the edges of the *Field* abuts a low-slung cattle fence. The first sense one has on arriving is of complete isolation, adrift in a sea of brown and tan and blue.

Robert helped us unload the car, then pointed out the amenities in the cabin. There were the usual staples in the kitchen—milk, eggs, coffee—and a container of cheese enchiladas

in the refrigerator, apparently the standard *Lightning Field* fare. The main room featured a few wooden chairs, a wood stove, and a long table with a bowl full of green apples seemingly placed by Pottery Barn. The bedrooms were equally sparse but comfortable, with walls that would give you splinters if you ran your hands over them. It was hot and bright, so we left the doors open and soon found out why every room had several flyswatters hanging on the walls. There was one very old phone, with Robert's phone number written in faded ink on an index card next to it. After making sure we knew where he could be reached, he drove off, leaving us carless and completely disoriented in the middle of the desert.

Todd and I were practically squealing with delight. It was rustic but in a Williams-Sonoma sort of way, exactly as one would imagine a cabin designed and maintained by Dia would be. We claimed our bedroom, the only one with a separate entrance and an attached bathroom, and headed out into the *Lightning Field*.

The work itself is a grid, measuring a mile by a kilometer, of four hundred seemingly identical stainless steel poles stuck at regular intervals in the ground. Think acupuncture, pin cushions, *Hellraiser*. In the living room, there was a thick binder that laid out all of the specifications of the work and the details of its construction. Though a basic description of the work sounds uncomplicated, this documentation tells a vastly different story.

Built over the course of a year, from 1976 to 1977, this *Lightning Field* was actually the second version of the work. An early version had been "tested" in Arizona in 1974. (All of the descriptions of the final version have an empirical cast, beginning with "Based on information gained through observation of the Test Field . . .") The *Lightning Field* was literally planned to within an inch of its life. Its largest unit is a mile—the long side of its rectangle—and the smallest is three-sixteenths of

an inch, the diameter of the interior poles that hold the outer stainless steel sheaths in place. It is an isolated area of mathematic precision set into an otherwise organic and presumably unaltered landscape. The individual steel poles, two inches in diameter, are set in a grid twenty-five by sixteen, at axially regular intervals of 220 feet. But it's more complicated than that: each pole, fitted over one of those three-sixteenths-inch inner poles, is engineered such that its tip, honed to "needle sharpness," is at exactly the same elevation as the tips of the other poles. All the slight rises and falls in the land have been taken into account; a massive sheet of glass laid over the work would rest equally on the tips of all the poles.

De Maria worked hard to find a machine shop that could fabricate the poles; apparently, many fabricators balked at sharpening the tips because only one end of the stock could be held in a lathe, rendering the process unstable and dangerous. In the end, the tips and poles were produced separately, then welded together, to De Maria's exacting specifications.

It took about six months for the machine shop to spin and polish the poles, four hundred for the initial installation and a number of extras to be used as necessary. Like Heizer, De Maria believed in the timeless essence of the work. He was not interested, as Smithson was, in seeing how the elements would reshape the *Lightning Field* but instead wanted it to remain in its original, gleaming state, which is why extra poles were fabricated. The extras are stored in a shed near Robert's property, and one of Robert's jobs is to inspect the work regularly for lightning damage or disrepair and to replace the poles as needed. Robert said that over the years "a few" poles had been badly dulled by lightning and replaced, but that on the whole he was impressed by how well the work—both its parts and its installation—had held up.

Before the poles could be installed, the site was extensively surveyed, using both aerial and land-based techniques, to

determine the precise variations in elevation and the corresponding variations in the installation of the poles that would be required to align their tips. The description of the survey in the binder is scientific and complex, involving things I'd never heard of ("laser transits") performing acts I'd never heard of ("photogrammatic surveys") to achieve data I still don't understand ("4000 stakes marking the exact elevation and location of 2000 points on two square miles of land").

With the grid plotted, the arduous task of installing the poles began. Work commenced on June 13, 1977. First, grounding rods were installed to the northeast of each plot point. Four-foot foundation holes were dug for each pole. This required destroying the relevant survey stakes, so a separate grid was set up for each pole, to preserve the proper coordinates. I got lost just reading the description:

> Strings were drawn between these points to form a cross, the center of which was the center of the pole and height of which was a known distance above the base of the foundation. Welded spikes at the bottom of the can held the base in position, a plumb bob, strung from a tripod, was used to find center. Once centered and leveled vertically, a stake cut to pass thru the can was driven and held secure by a flat board staked into the ground above. Once these cans had been accurately and securely positioned, Redi-Mix trucks were brought in to pour.

Here I tuned back in—pouring cement I more or less understood. I will leave it to individual readers to determine if the rest is unintelligible or just unintelligible to me. The foundations thus meticulously prepared, the poles could next be inserted. Special tripods were used to assist "two transit persons" in ensuring the poles were positioned correctly, and then they were locked into place with "hydraulic type cement." The crew began installing the poles in September and

placed the last one on October 31. Perhaps Robert had to miss a few classes here and there to complete his summer's work.

Totals? Four hundred poles, ranging from fifteen to nearly twenty-seven feet to accommodate the changes in elevation. Nineteen tons of steel; forty cubic yards of Portland cement and six thousand pounds of hydraulic cement; 8,651 feet of stainless steel tubing; 248.5 miles of linear transit measurements, with an accuracy of one-tenth of a foot in a mile. And twenty-five employees at various times over a five-month period. The final field is a rectangle measuring a mile by a kilometer.

But, as De Maria explicitly states in the binder, "The sum of the facts does not constitute the work or determine its aesthetics."

Having glanced at the binder over the matriarchs' shoulders, I headed out into the *Lightning Field* to "determine its aesthetics." It was probably four o'clock in the afternoon, and while the sun wasn't directly overhead, it was still very high and not yet screened by the distant mountains. The air was hot and dry, with a few clouds starting to build. My walk was reminiscent of the one to *Double Negative*, parched and dusty with brush that scratched at your ankles and flies that buzzed overhead. Except, of course, that here everywhere you turned there was a pole. Todd and I walked directly into the center of the work, on an axis with the cabin. We walked its perimeter. We walked the alleys and the angles, trying to stay excited when in truth we were both a bit disappointed. The poles didn't seem to do anything to the landscape or to our perception of it. In the searing afternoon light, the poles almost disappear, casting few shadows. Their surfaces appeared uniform and dull. It didn't take long for the voices on the porch to recede, which only furthered my sense of isolation and the hollowness I was feeling, having had even my relatively low expectations for the work deflated.

Todd continued to wander among the poles while I headed back to the cabin and joined the others, who were opening up their Zabar's wine and cheese, which they generously shared. We all sat on the porch as the day waned. Elena, the only member of the group who had been to the *Lightning Field* before, explained that on her previous visit, she had spent all of her time *inside* the work; this time she was only going to observe it from its edges. Miriam and Ruth said that it was too hot for them to be walking the field now, but they planned to go into it later. I learned more about them, about Elena's "tensile structures," about Miriam having been on the *QE2* with Jackie Onassis just before Jackie got engaged to JFK. "A lovely girl," she said repeatedly. "Her French was perfect."

Todd completed his survey and joined us on the porch, where he was mercilessly bossed around by the older women. "Todd! Bring Erin a chair out here!" "Todd! Won't you bring that knife in from the kitchen!" The matriarchs argued about everything, particularly Ruth and Elena. Apparently Elena could not enjoy herself unless she was disagreeing with someone about something: the merits of living in New York; acquisition policies at Thomas Hoving's Met; minimalist art; which cheese went best with which cracker; Ruth's late husband.

I was having a pretty good time but starting to dread a very long evening. With so few people present, it would seem rude to slip off to my room and read a paperback while everyone else was making conversation. And I wasn't feeling drawn back to the *Lightning Field*. It was clear we weren't going to get any lightning, and without that the four hundred poles stuck in the ground weren't giving me the charge I had hoped for. Is earth art a fraud? I asked myself as people chatted around me. *Spiral Jetty* was smaller than I thought it would be; the *Sun Tunnels* were nothing but an anxious frustration, lost in the desert, and even if I had found them, were only cement tubes that "aren't worth nothin' anyhow"; *Double Negative* was cool

but not earth-shattering; and *Roden Crater* was an unidentifiable peak in a crater field. While I had successfully pitched a tent a few times, gone swimming in the Great Salt Lake, seen areas and artworks I had only heard about, and navigated a cross-country solo driving trip, perhaps I needed to come to terms with the fact that this monumental art of the 1970s had turned out to be less than transformative. I had yet to have an experience that truly lifted me out of myself and reengaged me with a sense of awe and wonder. If pressed, I had to admit that the natural landscape was doing more for me in this regard than the works I was out there to see.

Or perhaps, I thought, as Elena vigorously defended her view that Europeans were incapable of producing grand environmental work, I was simply too jaded. Heather, the landscape architect I'd met at *Spiral Jetty* and *Double Negative*, was clearly having meaningful experiences of the spaces she was visiting, so much so that she made semiregular trips to them. But Heather also used words like *empowerment*, so maybe she wasn't a great yardstick for me. Lily and Michael, the young artist couple from Los Angeles who were also at *Spiral Jetty*, were enjoying themselves, but Lily was thinking of *Spiral Jetty* in terms of her own production, not solely as an aesthetic experience.

I thought back to my reading of James Elkins's book *Pictures and Tears*, which is both a historical and a contemporary catalog of the emotional vibrations art seems to set off in people. In presenting chronicles of the "hysterical tourism" of the nineteenth-century and more than four hundred letters from twentieth-century viewers who have wept in front of paintings, he is pushing at a fundamental question: Why does art move us? He writes of his own experience:

> I recognize my own limitations. My failure to weep a single certifiable tear for a painting cripples my understanding of some

paintings, shutting me off from a fuller response. . . . All of us in the tearless present share this liability to some degree. It is as if we are standing on a seashore in a fog: the crash of waves and the calls of seagulls are proof that something big is out there, but there is nothing to see except some watery sand right at our feet. The history of art is little more, in this respect, than a frail science dedicated to inspecting the odd seashell or a bit of drift-wood. (209)

Like Elkins, I operate mostly in "the tearless present," preferring, at one end of the spectrum, monochromatic sullenness to express despair and, at the other, shaky, guttural noises to express delight. So I was interested in his thoughts on this topic. Why don't we cry in front of paintings? he asks, and offers some theories: we're out of the habit; museums breed people with a "cool demeanor," and weeping is out of sync with the overriding contemporary emotion of irony; it's more comforting to think of paintings requiring "only domesticated, predictable emotions" (210). Citing a colleague, he puts forth the theory that painting might be somehow weaker than movies, poetry, architecture, and even music—the only medium ever to move *me* to tears. Elkins isn't happy about this climate of emotional constipation, particularly among art historians, and he goes so far as to offer some "recipes for strong encounters with works":

▶ Go to museums alone.
▶ Don't try to see everything.
▶ Minimize distractions.
▶ Take your time.
▶ Pay full attention.
▶ Do your own thinking.
▶ Be on the lookout for people who are really looking.
▶ Be faithful.

Sitting on the porch while Todd and the women talked, I couldn't remember all of Elkins's suggestions, but I did have a few of them in mind and was growing frustrated that I had set myself out within the best possible conditions for viewing—mostly solo, with an itinerary of just a few works out in the wilderness, no schedule to keep, and no distractions but my own anxiety—and was coming up empty.

I wanted to raise this issue with my companions but didn't want to admit that, yes, here I was on this wonderful trip, open to all kinds of moving experiences but proving to be, myself, emotionally insufficient. I wanted to discuss whether the problem was with the art or with me; I wanted to ask if my expectations were even remotely reasonable. Of course, Elena had devoted her life to making art, so she might just tear into me for even doubting that art was powerful enough for modern life. I also didn't want to turn this getting-to-know-you cocktail hour into something ponderous. But I resolved to talk to Todd about it later in the privacy of our room.

The sun was sinking, and the relentless heat of the afternoon was starting to abate. I looked out at the *Lightning Field* and realized that it had changed quite dramatically while we had been sitting on the porch. No longer were the poles static, dully lit rods effaced by the sun high above. They had come alive, reflecting every movement of the setting sun. They blazed with color that stirred, as the sun went down, in a slow wave across the entire field. Every moment was different; the shadow of every cloud created a new view; the poles were illuminated, shifting, pulsing. The tangle of alleys and vectors that one experienced when walking through the work sorted itself out into perfect alignment, every row and column marching into the infinite distance with a glowing symmetry and regularity.

While there was still light remaining, I went back into the *Lightning Field*. It was a wholly different experience than it

had been earlier in the afternoon. Earlier, the bright sun had rendered the poles mute; while I appreciated their order, they seemed static and speechless, Easter Island guardians of the American Southwest. But now, in the early evening light, the poles were singing. It was a chorus of soft hues—of pinks and reds and oranges, sunset colors distilled and embraced and refracted by the polished surfaces—punctuated by bursts of brilliance as the sun hit the poles at just the right angle. The regularity of the grid only heightened this effect; it made it easy to see the movement of the light from one area to the next, passing on across the field. It was gentle and completely absorbing. I walked the aisles between the rows, and with every step the vista changed. One axis blended into another; with each forty-five degree turn, I perceived a new alley, a new alignment, infinitesimally altered from what I had seen the moment before. I stood in one place and turned a complete circle; I faced the sun, then looked in the opposite direction. Every view was a revelation. Every single one of those four hundred poles was *doing something*; together they shimmered and undulated, like a cornfield stirred by a strong wind.

When the sun was almost gone, the last remaining light slid up the poles, and for a moment only their tips were visible. They all lined up, slightly pulsing against the darkening sky. They were an army of hope reaching upward; they were bearers of flame against the encroaching darkness; they signaled the meek attempts of humans to take part in the cycles of nature; they were desperate and lovely and organized and chaotic. They were plaintive and proud; they were powerful. They made me write sentences like these, think grand thoughts in an inarticulate whir, be grateful and humble.

It would be nice to say here that they made me weep, but they didn't. Instead they filled me with a cacophony of strong, vague feelings that never fell into any form I could define as a coherent experience. A warm, internal tornado? A heady

rush? Quiet exhilaration? Dare I suggest *joy*? It was all of this and more. It was simply and inexpressibly beautiful. *The sum of the facts does not constitute the work or determine its aesthetics.*

I understood then why lightning is actually incidental to the *Lightning Field*. Many friends who had visited the work had assured me, as I anxiously checked the Web for weather reports for Quemado, that it really didn't need lightning. Perhaps, when lightning hits it, it explodes into something monumental and sublime. But even without lightning, it is a phenomenal arena in which perception is heightened and enhanced with nothing more than natural, daily elements, the sun and the sky. No smoke and mirrors required.

All of us there that night had been relatively quiet and isolated as the sun set and we each pursued our own relationship to the work. Though photography is prohibited, each of us had brought out a camera and was taking pictures like it was the last night on earth. They all probably discovered, as I did, that trying to photograph the *Lightning Field* at the moments in which it truly starts to breathe is like trying to photograph a ghost or a hummingbird. A camera can record a scene but can't come close to recording an experience. That absence, that coming up short, somehow seems fitting and worth protecting, Dia's copyright to the work notwithstanding.

When it was fully dark, we all repaired inside for dinner without really commenting on what we had just witnessed. We stuck the enchiladas in the oven, made a salad, and uncorked several more bottles of our companions' wine. Conversation continued along the trajectories that had already been established. The women had known each other a long time and took shortcuts in their communication, aiming soft-tipped jabs at Elena, who always shot back with a sharper arrow, much to my amusement. The three of them insisted, with exaggerated deference, that Todd, the only man, sit at the head of the table. The meal was lively and pleasant and ended early.

After dinner we sat on the porch and marveled at the night sky and at our ignorance of natural phenomena. We actually argued about which constellation was the Big Dipper, which I had always thought was the easy one. Then Ruth distracted us by claiming that a blinking light was a UFO. That set off a lengthy and ridiculous argument about the source of the light. Theories included the completely implausible one that it was the light from a train moving on tracks laid across the top ridge of the mountains. I thought it was a light atop a communication tower. Miriam thought it might be a star. Elena argued that it was a planet. It was turning into that kind of night, so Todd and I decided to go to bed.

Our room smelled exactly like the outdoors. It had grown quite cold since the sun set, and we piled the wool blankets (L. L. Bean) on top of ourselves. I slept deeply and dreamed so vividly that I later recorded my dreams:

> Mick Jagger was my boyfriend and he kissed me in a parking lot where we had been getting my Adidas split-toe soccer shoes out of his car trunk. I was wearing a flimsy sateen purple prom-type dress. He started kissing me and we started flying up into the sky. I was looking at him in happy disbelief and he was doing the same. We kept kissing and flying. I looked at him and said, "Do you know why this is happening? It's because I like you so much!"

The next morning Ruth rapped on our door to wake us up for the sunrise. It was part of the instructions left by De Maria, published in *Artforum* in 1980 and also included in the binder:

> *The Lightning Field* is a sculpture to be walked in alone as much as possible—lie down, go to sleep, wander, find your place, be there at least an hour before sunset until it gets dark, wake with first

light and go out for dawn and sunrise. The cabin and porch are nice, but the experience is on the *Field*. It is a lot about space and time and silence and isolation. Be toward the west end at sunset and east end at dawn.

My watch read 5:54, and it was freezing. We stumbled out of bed and threw on sweaters and pants. Elena—one of those people used to getting up while it is still dark—was already in the kitchen making coffee, and she handed us each a mug as we greeted her and headed out the door.

Todd and I set off separately into the *Lightning Field* while our companions, wrapped in blankets, took up their spots on the porch. It was still dark, the sky still bright with stars, planets, UFOs, communication tower warning beacons, and train headlights. Light from the east slowly crept across the field, growing in strength and illumination as the sun came up over the mountain ridge. I had the same sense of measured growth, a swelling chorus, as I had had when it set the night before. But while the *Lightning Field* in the evening was ablaze and defiant, in the morning it offered a soft and slow awakening. Homer's "rosy-fingered dawn" was on a continual loop in my head as I watched it become embodied. It seemed as though the sun, with rosy fingers, was awakening the poles one by one, section by section. It reminded me of my particular childhood compulsion, a need to greet everything in my room before I could get out of bed: "Hello, dresser. Hello, closet door. Hello, night table. Hello, lamp." At first, each pole was reduced to a blade of white metal, but as the light crept up, each in turn was transformed, from sharp white to orange to pink to yellow.

My closest corollaries to the experience were auditory. It was as if what I was seeing was something I had only heard before. The sunset in the *Field* had been a chorus; the dawn a series of soloists that grew like the rolling waves of sound

locusts make. There's a rumble, a swell, a climactic moment in which all voices are heard at once, and then a denouement. The blast of white light that struck each pole turned into the thousands of beating wings that give a cloud of insects its peak volume before it settles into something less urgent and insistent. In this way the sun rose and moved across the *Lightning Field*.

I was conscious only of the crunch of my footsteps, the goose bumps on my arms, the rabbits that poked their way through the grid. I could feel the roar of insect wings as the light swelled and rippled. In the evening I could see the spatial array from wherever I stood, but at dawn I had to wait for it to be revealed. The night before, the linear arrangement of the poles had withstood the waning light. Even in the last gasps, when only the tips were illuminated, the order and symmetry were evident. But at dawn, the array grew before my eyes. Sections of the array remained unseen, then emerged instantaneously as they were touched by the sun, revealing the sheer magnitude of the work. What had been a dark alley showed itself as a broad, inviting avenue; the unmeasured depths filled with row upon row of neon tubes, like a Flavin sculpture. It was not just the individual poles or neighborhoods that were unveiled; it was the sense of choice and possibility. Vistas opened up, new views appeared with every footstep and ray of light.

This heightened sense of perception awakens in me whenever I think of that dawn in the *Lightning Field*. Writing this on a late spring afternoon in Chicago, I am acutely conscious of the mellow blood-orange light of the sunset as it comes in through the window at my back and warms the spines of the books stacked on my desk. Then the light simply fades and disappears. To live always in this heightened state must be nightmarish, overwhelming, but I imagine that most people, including me, could benefit from more of those moments in

which the atmosphere itself, the air and the light, becomes so powerful that one can't experience anything else, if only for a few seconds at a time. Perhaps this is what De Maria was driving at when he wrote, about the *Lightning Field*, "The invisible is real." Perhaps this what is Heizer was driving at when he spoke of atmosphere becoming volume.

When the sun was fully up, the *Lightning Field* faded. Its symphony subsided. I could hear the matriarchs clattering around in the kitchen. Elena called to Todd, "Todd! Ask Erin if she wants cheese in her scrambled eggs!" Todd, who was standing right next to me, asked me if I wanted cheese in my scrambled eggs. I said yes. "Yes!" he shouted back to the kitchen. As I walked toward the cabin, the *Lightning Field* was silent. The poles had become just poles again.

Over breakfast I turned on my tape recorder and asked what everyone else had experienced. Miriam had wished for lightning, but Ruth was satisfied with the day as it was. "I had an experience I didn't expect," she said. "As the sun came out, it was the flowers I noticed, not the poles. The colors just burst out. And the mountains too. Standing there I thought of Stonehenge. I would say it was almost a religious experience, but I don't believe in God. It was like all of a sudden I was in an ancient place."

"Yes, timeless," Elena said, for once agreeing with her. "The feeling that all of this had been here forever."

Ruth continued, "This morning I walked into the middle and I was getting a 360-degree experience of the sky as the colors changed. And in every segment of the sky there was a different view. Just unbelievable as the sun came out. I think I was thinking that way—not of the *Field* but of the landscape—because I saw last night as the end. For some reason it was the end to me. So this morning I went out there thinking not of the *Field* but about what was going to happen around it."

Todd agreed, saying that he went out into the *Lightning*

Field waiting "for the moment something would happen."

"And it did," Ruth said.

Elena asked for the butter.

I mentioned how conscious I was of the choices I had in the *Lightning Field*, how you can align yourself with one of a dozen paths, and how with a single step you can go from complete chaos to perfect order.

"Yes," Elena said. "I made a drawing the last time I was here to try and better understand how that happens. Wherever you put yourself, you get something different. And that, with the perspectival sense of these poles stretching into space, gives you a real sense of eternity and infinity."

"A mathematician could explain that to you," Ruth offered.

Elena drew herself up. "There is no need to explain; we don't need explanations to experience things. But it is one of those things that really works here—the layout, the distances. If it were any more, you would be walking into a forest that just goes on. If it were any less, you would have nothing."

I realized that this, of course, was the reason for the test site to which the binder referred.

Elena continued, "I just love this. I really think De Maria did this so perfectly in this way. It erases itself, and then it comes to life. And the manmade and the natural go so well together."

"They do go perfectly together," I said, "but they go so perfectly together that I felt like an interloper. Here I am, this irregular thing, moving around in this area of pure regularity. I kind of felt like I shouldn't have been here."

"I know!" Miriam said. "This morning I was so disappointed that I couldn't get a picture of anything without my shadow in it, like I shouldn't be here either."

"Is it the same thing you feel in the Grand Canyon, that this thing is so big and so completely independent of wheth-

er you're there or not?" I asked, thinking of Michael Fried.

Miriam thought for a minute. "No, it's not quite like that. There you have the sense that you don't matter, and you shouldn't matter, and that's the way it is. Here you do have the sense that you matter, because in a way it is built for you, for people to come and visit it. But at the same time that the *Lightning Field* is meant to be seen, you're pretty incidental to it. And you don't fit in it, as you said. We're not shiny poles."

I thought about mentioning that Elena was in fact Lithuanian, nearly a Pole. But I didn't.

"So you're out there wanting to be part of this thing," Miriam continued, "wanting to be in this thing but not included in this thing. In it but not included in it. It's about the sky and the light and symmetry and geometry, and that all exists outside of you. But at the same time it exists for you."

Elena said that this visit, in which she didn't even enter the *Lightning Field*, was more satisfying to her than the trip when she walked around in it. "I felt much better this time, seeing the whole thing from a distance. I got more of the whole feeling rather than the parts." *The sum of the facts does not constitute the work or determine its aesthetics.*

Ruth compared her experience to a trip she had taken to the Acropolis. "I had somewhat of this feeling in Greece. I went to Greece a long time ago, before there were entrances built to things, before you had to go through card shops to be anywhere, and being on the Parthenon at sunrise, just climbing up the side of the hill, was just as moving. There were no steps, no guards, and seeing the light come up there was an incredible experience."

"But De Maria has achieved the same effect by completely organizing space, adjusting space," Miriam said. "You remember your trip to the Parthenon because the space wasn't organized, but here it is completely organized."

"The Parthenon certainly was organized!" Ruth fired back.

"The way the light was framed by the columns, the way the land stretched out underneath it. It had an architect, it had proportions."

"Maybe it's like how you're supposed to feel going into the Field Museum in Chicago." Todd tried to bridge the gap. "The museum is an old neoclassical building, and the steps leading up to it are very deep, so deep that you can't skip one. They're just a bit wider than the average step. The architect there makes you slow down and take every single step on your way into the building. You have to appreciate that kind of control on an approach to a building. It has a pace to it."

"It's strange that it works so well, that its pace is so solid. I wouldn't have thought that a mile and a kilometer would go together very well," I said, revealing my inherent bias toward absolute uniformity. "I kind of wanted it to be a square, though now that I'm here I know it's perfect, but I don't know why."

Elena said, "It just can't be a square. The reason to me is very clear. De Maria wanted to make it universal, global. It is the ancient golden ratio. He must have learned an awful lot building the first one, the sketch, in Arizona. And anyway, you don't need to have the mathematics behind it to have a sense of what will work and what won't. It's as much trial and error as anything else. You try it and you fix it and you try it again. That is the essence of making something."

Ruth couldn't swallow this. "You think he did this by trial and error? I don't think so."

"Look," Elena replied. "You always have to start with trial and error. When you build something, when you build it at a larger scale, you have to change things. You have to take chances. There's no other way to do it." The tensile structures started to loom over us. "You don't know how it will work until it does. And *then* you go back and figure out why it worked; you think about what you changed and what the effect was. If

it's good, there will be some mystery to it. People might not get it because they might not have what one would call an educated outlook."

I didn't know where she was heading with this. If mystery is a component of the works that we'd been talking about, why would you need an "educated outlook" to appreciate them? The *Lightning Field* would be just as good without the binder-ful of information. While the binder enumerates the work's components and structural history, it can't possibly explain the effect of the assembled parts. Reading the binder is like reading a recipe. You know what goes into the mix, but you don't know how it will come out until you taste it. *The sum of the facts does not constitute the work or determine its aesthetics.*

We had finished breakfast but still had a few hours before Robert came back to pick us up. Todd and I cleaned the kitchen and packed up our things. We took one more walk in the *Lightning Field*, but at this point, for me, the poles were still silent. We hung out on the porch a bit more, and I frankly wished that Robert would come early because I was getting bored. I had come to believe—and still believe—that the *Lightning Field* comes alive only when the sun is hitting it a low angle. At other times, it is just hot, dry, isolated—and mute.

Robert finally came and we climbed back into the van for the drive to Quemado. We were pretty much done talking with one another, so I started asking Robert questions, as if he were Uncle Buck and I were Macaulay Culkin.

"Anyone ever get badly hurt out here?"
"No."
"Anyone ever die out here?"
"No."
"Anybody ever give birth out here?"
"No."
"Anyone ever get married out here?"

"Oh, sure."

"Anyone get sick out here?"

"Sometimes."

"Do you think people are ridiculous for wanting to come out here?"

"A little."

I asked him what was the strangest thing that had ever happened at the *Lightning Field*. He thought for a moment, then said, "Well, one time I came back to pick up a group, and as I drove up to the cabin there was a huge naked man sitting in a puddle he had made in the driveway with the hose. He was just smearing mud all over himself."

"Why?"

"Crazy, I guess."

The *Lightning Field* "works—or it can if you're open to it," says Michael Kimmelman. I'm not sure I agree. To me it works regardless of whether you're open to it. Its job, in fact, is to render you open to it. I think that's the reason for the mandatory twenty-four-hour stay. To see the sun set across the *Field* is to understand what it does; it prepares you to pay attention to the sunrise that will follow. It is critical to experience both. If I hadn't seen the effects of the sunset, I probably wouldn't have gotten up to see the sunrise. Here again, land art was proving to be less about space than about time. All of the works operated on cycles, as brief as a minute or a day and as long as decades. *Spiral Jetty*'s accretion of salt, *Double Negative*'s erosion and shadows, *Lightning Field*'s sunup and sundown. While all of the artworks frame and inflect their surroundings, drawing your attention to how they are placed in the world, they are all equally if not more engaged with the passage of time, whether geologic or personal. The experience is durational, not the all-at-onceness of the Picasso in the desert but the inexorable movement of the earth and the sun.

Some people stay at the *Lightning Field* for more than

twenty-four hours, and I toyed with the idea of coming back and staying longer. I ultimately decided that more time there might dilute the powerful experience that had redeemed my trip, aesthetically speaking. I spent my high school years in Honolulu, driving every morning at daybreak in a Volkswagen Rabbit from our house on the eastern tip of Oahu along the southern coast of the island to downtown Honolulu. I drove through countless spectacular sunrises as the light edged its way over the dim shapes of Maui and Molokai and spread across the Pacific. Perhaps it was because I was a teenager and thought more about boys than beauty, but I have only a vague recollection of what those sunrises looked and felt like, though I saw them five mornings a week for two years, from when I started driving to when I graduated. There were just too many of them to be memorable. I would hate for that to happen to the *Lightning Field*.

Chapter 7 } Juárez

Juárez, Mexico, is a dream and a nightmare, a nether zone where everything is recognizable but at the same time horribly off. It is nasty, bloody, filthy. I felt there was something dark at its core—the poverty, the hopelessness, the silent acceptance of a city, a life that should be utterly unlivable but somehow isn't. A low-level unrest settles on every curb and around the spindly trunk of every tree choked by car exhaust and drowned in the urine of thousands of men. The disquiet was pervasive and thick, a violent rumbling under the surface of everyday life, a tremor that the women tried to ignore as they went home at the end of their workday, hurrying past the knots of idle men who stood on corners and sucked their teeth. Between examples of near-clinical order—*Lightning Field* and Donald Judd's milled aluminum boxes in Marfa, Texas—lies this human mess, this border town under the twin spires of the Asarco smokestacks.

Todd and I decided to cross into Mexico because it was literally within blocks of I-10 as we drove south from the *Lightning Field* to Marfa. We had sliced down through New Mexico, laughing and joking and listening to music and doing what people do on car trips. The *Lightning Field* had filled me with an energy that flows from a transcendent moment in which you forget who and what you are in the face of something truly beautiful. The marvelous is invigorating, and I felt a second wind, ready to embrace the remainder of the trip after too much time spent spinning my anxious wheels out-

side of cell phone range, lost in the desert or on top of a mesa, worrying about the undercarriage of my car or the dwindling amount of cash in my wallet. So as we hit El Paso late in the afternoon, with our hotel reservations in Marfa confirmed for later that night, a stop in Juárez seemed almost necessary. Todd had never been to Mexico, and the idea that I could be with him in a country he'd never seen before was further incentive for making the stop.

It was a Friday afternoon, and the two border checkpoints, surrounded on the Texas side by one-story stores with plate-glass windows and two-dollar T-shirts, were taxed. Cars sat idling for blocks as drivers waited their turn to cross. Road construction only exacerbated the mess; sawhorses and blinking orange lights and traffic cones and gutted sidewalks strangled the lines of waiting cars. I decided to park the car in Texas so we could walk over instead. It was partly the wait at the border but mostly the knowledge that my car contained a high-end laptop and iPod, hundreds of dollars of camping gear, clothes, food, cameras, books, and even a few DVDs. I didn't want to park the car somewhere and then worry about it; even less did I want to park the car somewhere, pay someone to watch it, and return to nothing. Yes, I was paranoid.

We parked in a garage about five blocks from the border and fell into the stream of end-of-the-working-day foot traffic. It was hot and the sidewalks were crowded; women carried children and giant plastic shopping bags; kids darted around parking meters and piles of merchandise laid out in front of the shop windows. People clustered around tables heaped with cheap clothes and offbrand cleaning supplies. The crowd was moving inexorably toward Mexico.

The plan was to cross into Juárez, sample the local color by eating a taco and drinking a beer, then walk back to Texas, pick up the car, and head for Marfa before it got dark. The Rio Grande between El Paso and Juárez is a dirty trickle at the

bottom of a ditch, a dried-up stream that makes the epithet *wetback* seem like an oxymoron. We crossed the Friendship Bridge with no fanfare whatsoever, and it spit us out on a busy street flanked on the north by a complex of grim customs buildings and on the south by a small plaza at the intersection of busy, loud streets.

A cursory glance at the Triple-A booklet had directed us to seek the cathedral in the center of town, which is surrounded by a "bustling" outdoor market. If we had a destination, I suppose that would have been it. But instead we wandered and floundered and tried to cross the busy streets with no real idea where we were headed. An old man could tell we were directionless and tried to help us; Todd got into such a protracted discussion with him that I was sure it was only a matter of time before he asked to be paid for his assistance or one of the clumps of idling men made us as easy gringo targets. I hissed at Todd, "let's go let's go let's go" and tried to pry him away from the old man, who was waving his arms to the south as we stood there uncomprehending. We rounded the nearest corner and followed the signs toward "central." They landed us on a street filled with bridal stores—big puffy white synthetic dresses, confections, veils and tulle and nylon and elastic.

I was surprised by how busy some of the stores were. I'd have grouped them with Christmas shops, stores with such a specific audience that one wonders how they stay in business. But wide-hipped women and sheepish men kept coming out of them, onto the sidewalk and into the street. The sidewalks were perilous—jagged chunks of colored concrete, mini mountain ranges to be navigated with caution. The curbs were either three feet high or nonexistent. Todd said it didn't look like the Mexicans with Disabilities Act would pass any time soon.

After about three blocks in Bridal Alley, we made an arbitrary right onto a very broad street lined with fast food res-

taurants and dollar stores. The sidewalks were packed with late afternoon crowds, and the street with five or six lanes of one-way traffic, seemingly all ancient Volkswagens. This was apparently the street that would take us to the cathedral. The sun was setting, illuminating the dirty back windows of the cars and lending a rosy tint to the thick and dirty air. If it were cleaner, it would have felt paradisical and languid; instead it stuck to our sweaty skin and formed a gritty crust.

We both wanted to take pictures but didn't want to pull out our cameras. We both wanted to eat something but didn't want to pull out our fifty-dollar bills. We both wanted to talk but couldn't manage a conversation with so many people streaming around us. We both wanted to give up and return to El Paso, but neither of us wanted to admit that. We just bumped along in an awkward silence. I hadn't eaten since that morning, but my hunger lessened with every block. My dream of a frosty beer and tortillas with carnitas evaporated. Every restaurant looked like dysentery or a tapeworm waiting to happen. The establishments were storefronts without windows or doors, literal holes in the wall with bleak, exposed kitchens and standing-room-only counters. Men with greasy hair tended big vats of muck; women with dirty fingernails chopped and stacked without lifting their heads. Flies lined the walls and the counters. No one noticed and few spoke.

Somehow, from the multilane road, we made our way to the cathedral. As Triple-A had promised, there was a large outdoor market set up on the plaza around it. Vendors sold soft drinks and trinkets under blue plastic tarps covered with dirt and reeking of mold. I was overwhelmed by a sense of filth. I wanted a soda but saw them sitting in a beat-up cooler, swimming in water and ice I knew would make me sick. I thought about picking a can out of the cooler, getting that water on my hands. I thought about microscopic drops of that water seeping into the membranes of my mouth. I thought about

inadvertently rubbing my eye with a finger that had been in that water; I thought about eating food with the hand that had been in the water. I visualized the epic battle between the bad water and my sheltered gringa immune system. I felt the flush of fever, the cramps of diarrhea. I skipped the soda.

The plaza was crowded. Todd and I bobbed and weaved, turned sideways, kept our gaze low except when throwing each other worried looks. We wound up and down the aisles, trying to look interested in the wares: cheap cassettes, plastic toys, candles, paper towels. The entire plaza reeked of urine and sweat. Men argued under the blue tarps. It was time to go somewhere else.

In a different mood, on a different day, with a little more time, we might have stuck it out, made a day of it, gone beyond the blocks so close to the border in search of the less-diseased heart of Juárez. I'd like to imagine mom-and-pop kitchens with heaping plates of hot, wholesome food and perhaps a shy teenager who would, in his broken English and our broken Spanish, tell us about crannies of the city that concealed things to be appreciated. Instead the streets and sidewalks grew more crowded and we grew more anxious.

Todd said later that it was the ubiquitous clots of four or five men, just standing around on the sidewalks and street corners, watching us pass, that made him so nervous. "I have never seen so many men doing nothing in one place," he said. I was afraid they would mug us, with our digital cameras and big fat American wallets shoved deep in our pockets. Todd was afraid of something more brutal; with his khaki shorts and plaid shirt and expensive glasses and ankle boots, he saw himself branded as a *maricón*, a punching bag for the unemployed, broke, and dirty men who stood between us and El Paso.

On our way back toward the border, we turned a corner and saw a massive crowd moving restlessly outside what looked like a nightclub. There were probably a hundred peo-

ple, mostly men, hovering around the front doors. I wanted to go see what had captured their attention, figuring that the middle of a curious crowd was probably one of the safer places we could be. Policemen arrived on mopeds, splitting the crowd and heading to the front doors. It was Todd's turn to urge me on.

The streets we were taking back to the border were filled with clubs of a questionable nature. "American disco!" was painted on the shutters of one; "cheap beer," read a sign hanging from the second-floor balcony of another. The buildings looked worn and distressed, trying to rouse themselves for yet another Friday night in a border city. The crowds continued to move in waves with something sinister at their base. Todd and I were trying to keep track of where we were going without losing each other, but we kept getting separated. Todd was on the left, closest to the buildings. A teenage girl in filthy clothes passed us going in the opposite direction; I looked at her face as she moved past us and saw a gaping hole where her left eye should have been. My gaze was drawn to a gap in the crowd on the other side of the street. At its center was a man stumbling and shuffling toward the cathedral. He was shirtless and covered with dried blood; a flap of skin hung from his chest like a pocket ripped from a shirt in a bar fight. The sidewalk traffic simply parted for him.

When I returned to Chicago I read obsessively about Juárez. Though I have been in Mexico many times before and since, though I have seen the slums of Lima and the red-light districts of Berlin, I had never seen anything like Juárez, and I struggled to find out what made it so different, so much more terrible. I read about the *maquiladora* murders, the corrupt *federales*, the staggering parallel economy of drug trafficking that reaches the highest levels of the Mexican government. I read about life in the *colonias*, in Juárez and along the southwestern border more generally; I devoured books about *pol-*

los trying to cross into the United States and being left for dead in the Arizona desert. I read about American teenagers being abducted from the clubs along Avenida Juárez, which turned out to be the street with the pulsing crowd and, not coincidentally, the street I later read in the Triple-A book that American tourists should stay away from. I pored over books of images by the street photographers who are always on call in the city. I digested Noam Chomsky's essays on how trade agreements like NAFTA are signed on the backs of the already impoverished. I learned how much prostitutes charge and about the vast areas of the city where there is no running water or sewer systems. I saw a great deal on my trip through the West, but nothing has remained with me like the smells and sounds of Juárez, the absolute sense of dislocation and alienation, which was translated, in my gut, as fear.

I trust what Charles Bowden has written about the city:

> You are tasting something we seldom talk about: horror slapping our systems awake and making us feel more alive than the gardens we cultivate with love during the better hours. Juárez is a depressing place and Juárez makes us feel more alive. . . . I believe that Juárez is one of the most exciting places in the world. I am struck by the electricity that snaps through the air in a city saturated with grief. (*Juárez*, 41)

Chapter 8 } Marfa

The final stop on my tour was Marfa, Texas, about three hours southeast of El Paso. Marfa is, in the United States, the contemporary art pilgrim's mecca. A hardscrabble settlement, named by a railroad engineer's wife after the faithful servant of Dostoevsky's *The Brothers Karamazov*, Marfa (population 2,500) is riven by deeply entrenched divisions between the area's Mexican population and the white ranchers who have lived there for generations. The town first became famous as the place where the 1956 movie *Giant*, starring Elizabeth Taylor, Rock Hudson, and James Dean, was filmed, and was given a second wind when the artist Donald Judd started poking around in the early 1970s. Judd, who died in 1994, began his career as an artist as an expressionist painter in New York. Abandoning that medium after limited success, he became a sculptor of "specific objects." Anointed the leader of the minimalists (a term he despised), Judd was given a retrospective of his work at the Whitney in 1968, at the early age of forty. Shortly after this apotheosis, his attraction to the West, coupled with his ambition to install his art in more permanent venues than galleries and museums, led him to rent a house in Marfa.

That modest rental was the first step in building a real estate empire and contemporary art outpost. Over the decades, Judd bought building after building in Marfa, then a sixty-thousand-acre ranch abutting the Chinati mountain range outside of Marfa, and then—with Dia's help—an aban-

doned army base on the edge of the dusty town. He formed
the Chinati Foundation and transformed the army base into
a contemporary art complex, which opened in 1986. Marfa is
the physical manifestation of Judd's belief in the permanence
of objects and their highly specific installation. Art, for Judd,
was not a series of mobile objects to be picked up and moved
around. His will is explicit on this point: "Works of art which
I own at the time of my death as are installed at 101 Spring
Street in New York City [the five-story building he purchased
in Soho in 1968] or in Marfa, Texas, will be preserved where
they are installed."

It might seem that the metamorphosis of Marfa epitomiz-
es cultural philanthropy and the transformative power of art,
but that belief belies the fact that Marfa has always existed
at the tense intersection of the haves and the have-nots, and
the presence of Judd's work, however well intentioned, has
exacerbated those tensions. These days one hears a great deal
about the residents' resentment toward the hoards of art tour-
ists, the real estate developers, and the skyrocketing property
taxes that are driving them from their homes. But this is only
the latest chapter. William Langewiesche's excellent *Cutting
for Sign*, a group of essays about life on the U.S.–Mexican bor-
der, describes Judd's uneasy existence in Marfa, difficulties
that eventually drove Judd farther south to purchase Cande-
laria, an even smaller town closer to his ranch and smack on
the Rio Grande. There Judd had hoped to recapture what he
had first seen in Marfa, before he and the town soured on each
other. Langewiesche writes:

> Like most outsiders to Marfa, [Judd] sympathized with the Mexi-
> cans. Although he had made a fortune with his art, he rented
> a small house in Sal Si Puedes ["Get Out If You Can," then the
> oldest and poorest Mexican neighborhood in Marfa]. I am sure
> he paid generously for it. Later he hired locals, mostly Mexicans,

to install his art, and offered them medical benefits and big salaries. He created a nonprofit foundation for the installation of more works, directed it to buy the old army base and much of the abandoned downtown, and made a point of keeping the properties on the tax rolls. He tried to bring new ideas to the town. He sent his children to the public schools. He was too wise to expect gratitude but perhaps too absorbed to anticipate the hostility he engendered. He ran for the school board and was crushed. The ranchers said he was subversive. The Mexicans called him a fool. (180)

Though he tried, Judd wasn't able to bridge the century-old divide between the Mexicans and the ranchers. Despite his becoming involved in local politics, sending his children to local schools, and pumping money into the town's economy, Marfa and Judd were never an easy fit. Langewiesche describes a drive with two Mexicans who worked for Judd, how they were "rebellious and servile" at the same time, driving Judd's truck hard through his property, throwing empty beer cans on the floor, delighting in their own hostility. According to Langewiesche, Judd was aware of the antipathy and began to spend more time on his ranch, eventually looking to Candelaria for what he had originally sought in Marfa.

Little of this history is visible to the art pilgrims who blow into town for a weekend, stay at the expensive hotel, and revel in the gold mine of art that Judd assembled. Todd and I were exactly that sort of pilgrim. While I had investigated Judd's involvement with Marfa, this troubled past was not evident on a visit as shallow and fleeting as ours. It is easy to ignore, on the one hand, the displaced and impoverished Mexicans looking for work amid the loft developments and, on the other, the husks of ranches that once economically propped up the region. Both sides have suffered over the past century. Divisive fights over the school board, property raids, a gun-

slinging past—everything that Langewiesche describes no doubt informs the evolution of every block and acre, but all of it is hidden from outsiders behind a curtain of polished aluminum, sans serif type, and the decidedly urban menus offered by most local restaurants.

As Todd and I left El Paso, I realized that the setting sun was now behind me. I was beginning the journey home, wending my way east and, soon, north: Marfa to Midland, Midland to Oklahoma City, Oklahoma City to Chicago. My trip was nearly over. I had seen the monumental work I set out to see. Marfa functioned as a transition to the art world I knew, a world of galleries and museums rather than mesas and lakes. Here the earth art of the West would be scaled down to gallery work sited in the West, which would be further diminished, by the time I got home, to gallery work sited simply in a gallery. Nostalgia was already creeping into my mind, and the utter absorption and fulfillment I had experienced at the *Lightning Field* was passing into memory.

Todd and I were quiet on the drive to Marfa, in part because we were both still processing the blood and grit of Juárez and in part because I was wrapped up in these thoughts of finality. Todd dozed as I drove and listened to appropriately melancholy music. As during my drive up I-25 in New Mexico, it was pitch black beyond the feeble reach of the headlights, and there were few other cars on the road. The night sky blended with the unillumined landscape, as if we were moving through a massive, undifferentiated tunnel. I became aware at some point of a bright light coming in over my left shoulder. Assuming it was the headlights of a car approaching behind me, I slowed down to let it pass. Minutes went by yet nothing passed me, and the light remained at my shoulder. I slowed down even more and pulled over to the right slightly, now convinced that I was going to be mowed down by a drunk redneck or a police cruiser, but still noth-

ing passed. By now the light coming into the car was shining brightly enough to wake Todd. "What's going on?" he asked, sitting up and craning his head around to the back seat.

"I don't know. I guess this asshole just wants to harass us."

Todd couldn't see anything behind us, and I couldn't see anything in front of us. A rhythmic noise slowly began to fill the car. I turned down the music so we could try to locate its source. Then suddenly the light exploded as the noise grew deafening. To my left, a train moving parallel to our two-lane highway burst from the darkness. A single headlamp sliced through the night. We hadn't even noticed the tracks, but there we were, barreling down a deserted Texas highway at seventy miles an hour with a train slowly gaining on us. It was ludicrous and fantastic at the same time, Magritte's *Time Transfixed* coming to life in west Texas.

The magical appearance of the train, now pulling into the darkness ahead of us, lifted us out of our funk, and the winking outline of Marfa soon appeared on the horizon. We had called the Hotel Paisano—the Ritz-Carlton of Marfa, home to Taylor, Hudson, and Dean during their movie shoot—from El Paso and were lucky to get two nights there. After weeks of Motel 6s and that tent, the Paisano would be utterly luxurious.

We pulled into the hotel parking lot after 10:00 PM. The town, despite its being Friday night, was dead. The buildings were dark, the shutters down, the streets deserted. At the hotel the front doors were shut, the lights in the lobby were off, and the fountain in the entrance courtyard was silent.

"How can a hotel be *closed*?" Todd whispered, as if someone would hear us.

The only signs of life anywhere were around a table on the patio entrance to the hotel. There a party of five or six people sat in the dark, drinking beer from bottles. We left our stuff in the car and walked the length of the patio to the lobby. The group offered a vague welcome ("Hey") as we made our way

past them to the front door, to which someone had taped an envelope labeled "Erin." Inside the envelope was a note, welcoming us to the Hotel Paisano and apologizing for not being here to greet us, and a room key.

We went back to the car, grabbed our bags, and crossed the cool tile of the vast, dark lobby, which looks exactly like an old-school Texas hotel should look. In our room, I crawled into bed with a fairly recent *Texas Monthly* article on Marfa, once again doing my homework at the last minute. On the second page of the article was a picture of Liz Lambert, one of the beer drinkers from the patio; a native of Odessa, Texas, she had made a name for herself as the real estate developer behind the Hotel San José and Jo's Hot Coffee in Austin. She had now turned her sights on Marfa and was working on two hotels in town, catering to its second life as a contemporary art center.

The Chinati Foundation, the main draw in Marfa, offers tours on a strict schedule, two-part excursions that begin at ten o'clock in the morning and convene again at two in the afternoon. After a long day that started at *Lightning Field*, included Juárez, and finished in Marfa, I wanted a full eight hours of sleep and a good breakfast before embarking on this next marathon. In the soft bed of the Paisano, I was out cold within minutes.

Dia and Judd were intimately connected until the early 1980s, according to Tomkins, when they had a falling-out over several issues, including Dia cofounder Heiner Friedrich's desire to "control" the Marfa installations in exchange for funding their rehabilitation and Judd's suspicion that Friedrich's commitment to Sufism was drawing funds away from Dia's projects. Judd's Chinati Foundation thus took over Dia's stake in Marfa and allowed Judd to reign unfettered.

Named for the nearby mountain range, the Chinati Foundation was started by Judd in the late 1970s. Its mission statement, penned by Judd, is unequivocal:

It takes a great deal of time and thought to install work carefully. This should not always be thrown away. Most art is fragile and some should be placed and never moved again. Somewhere a portion of contemporary art has to exist as an example of what the art and its context were meant to be. Somewhere, just as the platinum-iridium meter guarantees the tape measure, a strict measure must exist for the art of this time and place.

This official quotation, which appears in the Chinati brochure, leaves out the sentence that follows in the original statement: "Otherwise art is just show and monkey business."

The Chinati Foundation supports, and Fort D. A. Russell—the converted army base—embodies, that "strict measure . . . for the art of this time and place." Judd followed many other artists, including Heizer and De Maria, in advancing passionate and authoritarian views on art. These men held that art is an arena of consequence; they reintroduced the idea of the artist as a figure yoked, throughout history, to serious inquiry and the enhancement of humankind rather than to personal expression or consumer production. The artist is both cultural shaman and custodian. Even the language of Judd's rationale for the existence of the Chinati Foundation—"never," "meant to be," "strict measure"—is filled with imperatives of the eternal.

Judd's commitment to the idea of context is legendary. In a *New Yorker* profile of Friedrich and the Dia Foundation, Tomkins states that it was Judd's "impassioned conviction" that "the context—the way a work was installed and presented—was as important as the art itself" (Tomkins, "Mission," 49). So, while little of Judd's production was monumental or destined for the land, it is as fiercely tied to its surroundings as the *Lightning Field*, *Double Negative*, and *Spiral Jetty*.

While these other works fold in a certain level of interaction with elements beyond the artist's control, such as ero-

sion, salination, and lightning, the presentation of Judd's work is almost clinical. No aspect of its display has been left to chance. Light and space are harnessed and contained; certain works have been designated to be viewed at certain times; above all, permanence is stressed. Tomkins describes Dia:Beacon as the embodiment of Judd's vision: "the austere, naturally lit, industrial-space functionalism that Judd was among the first to identify as the right context for his work and that of his contemporaries" (Tomkins, "Mission," 51).

At the Chinati Foundation the next morning, Todd and I waited to begin our tour and talked about how Judd's aesthetic—large spaces, natural light, few works given lots of room—has become the standard way to display art, despite its relatively recent appearance in the history of installation. Well into the twentieth century, the standard was quite different. The "salon style" of hanging, so named because of its origin in the French academic salon dating back to the eighteenth century, was characterized by paintings hung one above another on the walls of galleries and museums, crammed and crowded into every available inch of vertical space, with ornate frames battling for attention with their equally ornate neighbors. This style was replicated in the "drawing room" feel of many early art galleries, and it started to change only in the 1930s and 1940s in the United States, when such institutions as the early Museum of Modern Art and the Museum of Non-Objective Painting (which would later become the Guggenheim) opened up the exhibition space and started isolating works on their walls. Private galleries soon followed suit, driven in part by the monumental paintings produced by New York school artists in the 1940s, which were so large they simply couldn't be tightly installed.

The "hygienic" or "white cube" viewing environment, which reached its peak with Judd, is thus of relatively recent vintage, though it has become so culturally ingrained as to

seem completely natural. In museums, galleries, and even private homes, paintings and sculpture are given generous space and attention—a complete reversal of the way art was displayed not a hundred years ago.

The galleries of the Chinati Foundation can be found throughout Marfa; the morning and afternoon tours take you from the army base to downtown Marfa and back again. The army base alone comprises 340 acres, with installations spread across two artillery sheds, a dozen barracks and multiple-use buildings, and outdoors, in the landscape itself. In town, the foundation has converted a number of buildings, including a former wool warehouse, into exhibition spaces. Viewing art in this complex of settings is very different from doing so in a museum, a fact that Chinati trumpets; its brochure even quotes Michael Kimmelman, who describes the experience as an "anti-museum . . . the opposite of today's populist palaces for spectacle architecture and revolving-door installations. . . . The impact is hypnotic. . . . There are few places in the art world where an equivalent stillness exists: not the socially mandated silence of public museums, but a stillness that seems to have physical weight." Tomkins echoes the sentiment: "Marfa is very far from the usual museum experience. No noise, no crowds, no gift shops or restaurants, and no alien objects to intrude on and distract the mind" (Tomkins, "Mission," 52). So while the general principles of installation at Chinati and in a museum are parallel, the ethos is not.

The Chinati galleries are designed to foster absolute and sustained communication between a viewer and an object, in much the same way that the *Lightning Field*'s overnight sequestration encourages its being experienced over time. In this sense, Marfa fits into the paradigm of the art I had seen on this trip. The work there may not be monumental in the same way, but it too counters the museum experience of rushing past works from different artists and different periods all in

the course of an afternoon. Such haste and chaos is anathema to really coming to terms with the objects in front of you, whether they be four hundred poles or a milled aluminum box placed on the floor. "Nobody who goes to a museum needs to see a Manet, a Monet next to a Cézanne and a Sisley, and whatever. The height of all this is now [2003] the Matisse-Picasso show, you know, bang-bang, bang-bang, bang-bang," Friedrich told Tomkins. "This is such a misunderstanding, to consider art just in comparison. Comparison means nothing!" (Tomkins, "Mission," 53).

The Chinati Foundation's tours allow about five hours to see the art in Marfa. Fort Russell itself contains not only works by Judd but, among other things, installations by Ilya Kabakov, Dan Flavin, and Roni Horn; a series of drawings by Ingólfur Arnarsson; poems by Carl Andre; and an outdoor sculpture by Claes Oldenburg and Coosje van Bruggen. In downtown Marfa a large warehouse contains work by John Chamberlain. And there is also (though not part of the official tour) Judd's "downtown" home, a compound of living and working spaces that take up a square block of Marfa land, commonly referred to as "the Block."

Given Judd's authoritarianism and insistence on order, I was expecting that all of Chinati—as well as "the Block"—would offer variations on the themes of rectilinearity, austerity, and seriality. After all the organic curves I had subjected myself to on this trip, I was looking forward to an environment of edges and planes within which I could feel fully comfortable, gridded, at ease. And for the most part it was. But there was also work that I didn't expect to see, objects and installations that seemed to fall far outside the boundaries of austerity set by Judd. Marfa is not so much a supreme demonstration of order as the site of an argument between order and excess. In the same way that I had teetered between the sublime and the intimate at *Double Negative* or between time

and space at *Spiral Jetty* and in Moab, I found myself caught between two impulses as we traveled from site to site.

A little after 10:00 AM, we were introduced to our guide, with whom Todd immediately fell in love. A soft-spoken, shaggy-haired wisp of a man, he was in the graduate school of design at Harvard and had come to Marfa for a summer internship, which consisted, as he described it, mostly of polishing Judd's aluminum boxes, leading tours, and spending his evenings trying to find something to do. Interns are given a small stipend and living quarters in the barracks at the former army base, the furniture and interiors of which were designed by Judd. Our guide was personable and articulate. With a few other people—including a guy from Chicago wearing the brightest yellow shirt Todd and I had ever seen—we headed off to the first stop, the two artillery sheds that house "what many Judd fans consider his masterwork: a hundred milled aluminum boxes" (Tomkins, "Mission," 52).

Judd wanted these boxes, *100 untitled works in mill aluminum* (1982–1986), to be seen in generous daylight, and to this end, he completely reworked the artillery sheds. He took out the garage doors, formerly used to move equipment in and out of the buildings, and replaced them with floor-to-ceiling quartered windows (Judd was obsessed with the four-square). He also added vaulted roofs to both buildings; he wanted to glaze the ends of the roof vaults for yet more light but abandoned the idea because of funding problems. He left untouched, however, some of the original graffiti that the army had left behind after using the buildings as a German prisoner-of-war camp during World War II.

Each of the aluminum boxes has exactly the same exterior dimensions: forty-one by fifty-one by seventy-two inches. Yet each box is different. In these two sheds, the rows of highly polished boxes stretch in front of you, minute variations on the same theme. The final dimensions of the boxes were

decided only after the renovation of the artillery sheds was under way, because Judd wanted the boxes to be in direct proportion to the windows. Like much of what I had seen on the trip, the mathematical relationships are carefully plotted. Smithson's "intuitive" correction of the coil on *Spiral Jetty*, after it had been completed, is light years from the geometric precision of De Maria and Judd. The exactitude of the latters' work is a main part of its appeal for a grid-thinker like me.

The artillery sheds housing the hundred boxes are serene and tranquil, rich with detail but never overwhelming. The installation presents the viewer with choices: long views down three rows of identically shaped boxes? A close view, moving box to box, to determine their differences? Planes and angles and edges are everywhere, but the effect is surprisingly gentle. Again, like De Maria or the garden designers of the eighteenth and nineteenth centuries, Judd offers a thicket of angles, vectors, paths, and options—a modern-day version of the picturesque. Daylight bathes the works but parts of the rooms are always in shadow, giving viewers a place to rest beyond the sheen of the aluminum, the cool and the hot.

Some of the boxes have planes that float above their flat surfaces; others are dissected by interior planes that form parallelograms and pyramids inside them. The scale of the boxes is inviting; to me that means that I could imagine crawling through them or sitting on them. They are imposing enough to avoid being labeled minimalist decoration, like storage cubes one might find in a Design within Reach catalog, but small enough to be approached, inspected, conceptually prodded.

"Sheet aluminum is sheet aluminum," Judd once said, and that pretty much sums up his approach to material (he also said, derisively, that "an imitation wooden surface of plastic is the symbol of the century"). He strove constantly to maintain the integral relation between a work and its material. Though

some have criticized the work for its clinical uniformity, it is impossible to sustain this objection walking through the artillery sheds. Personalities emerge from the boxes; some, with their sharp interior pitches, seem vaguely dangerous, while others, featuring floating planes, seem hopeful and ethereal.

The boxes also respond to the viewer's movements. At points I was casting a shadow on the boxes, my dark shape joining an edge here or breaking a plane there. The polished surfaces are highly reflective, so you can see your own movement through the surrounding space. None of these perceptions, of course, would be possible if the boxes were installed against a wall or in smaller numbers. To have their full effect, the boxes must be seen in the round; there has to be sufficient light and space for even Friedrich's debased "comparison." Judd's dictatorial installation strategy, which in certain moments outside of this context may seem monstrous and/or crazy, starts to make perfect sense. "They're just boxes!" you want to say, aghast at the millions of dollars this notoriously antagonistic, opinionated artist squeezed out of Dia for the refurbishment of Fort Russell. But here in the middle of it, in this cloister of aluminum, you have to admire the success of his vision. The work here is receptive to sustained examination and full of its own odd allure.

"[Judd] restored to art a dignity that becomes a moral point," wrote Michael Kimmelman, "a metaphor for how to deal with each other, which is to say, one at a time and patiently" (Kimmelman, *Masterpiece*, 194). This is precisely the experience created for visitors roaming the artillery sheds. The boxes have a purity and calm; things in and of themselves, they are trying to communicate nothing more than the reflection of what you bring to them. And they reward your patience and care, as *Lightning Field* does.

Later in the day, and against the rules of the foundation, we had lunch with our tour guide. He was reluctant but Todd

proved quite persuasive, so we went out for pizza with him and Yellow and his wife (Mrs. Yellow), the Chicagoans who were in Marfa on a birthday trip. During our meal, eaten on a dusty patio near the single intersection that was downtown Marfa, the guide told us that he thought it was a shame that the tour limited people to seeing the aluminum boxes when the sun was high.

"We cleaned them yesterday at dawn," he said. "And it was beautiful. The way the light was coming in, the boxes looked golden. Or really copper, like they were made out of copper. They were picking up all the emerging rays of the sun, just soaking in them and throwing them back at us."

"Why aren't we allowed to see it that way? Why do they schedule tours only when the light is kind of harsh?" I asked him.

He wasn't sure. He thought it was because Marfa is so far from everything that it wouldn't be fair to have people in at dawn or sunset. "They're always going someplace else or coming from someplace else," he ventured. "Like maybe they don't want to be here at six o'clock in the evening because they've got to get to Arizona that day or something. That's why the tours start kind of late in the morning and stop by four."

While it would certainly have been a different experience to be among the boxes when the sun was low, in a way it didn't matter, just as it didn't matter that we hadn't seen lightning at the *Lightning Field*. The experience of seeing this army of aluminum, each box working in itself and in concert with a viewer's progress through the rooms, was enough. A mere day after our visit, *Lightning Field* was already imparting its lesson.

"For years I had been seeing Judd's work in museums or New York apartments," Tomkins wrote. "My reaction to those stark cubes and stacked metal wall boxes was dutiful: High Minimalism, not much fun, but probably good for

you. In Marfa I got a sense of what I'd been missing. It was the element of time. Judd's boxes work on you over time, and through movement, and, yes, the context matters. As you move among these softly shimmering boxes, the shapes and the light and the space seem to interact not only with each other but with your body, so that the experience is not just visual" (Tomkins, "Mission," 52).

After lunch, we returned for the afternoon session at Chinati, beginning with the six bunkers that contained Dan Flavin's permanent installation. Flavin and Judd had been very close, so close that Judd named his son "Flavin." But there was a monumental falling-out—not uncharacteristic of Judd's relationships—and the two artists did not speak again for the rest of their lives. Early on they had planned a Flavin section at Marfa, but it stalled when they hit their impasse. After Judd's death, Flavin revitalized his plan for the Chinati Foundation, and work resumed. Flavin died in 1996, just two years after Judd.

Flavin's installation was unveiled at the annual Marfa open house in 2000. In scale and conception, it is as large as Judd's, occupying six U-shaped barracks buildings. At the base of each U, within the passage connecting the two parallel wings, two parallel corridors, in the form of tilted rectangles, have been constructed. These corridors, as described by the Chinati Foundation, "contain light barriers that are placed alternately in the center or at the end of each corridor. The barriers consist of eight-foot-long fluorescent light fixtures, occupying the entire height and width of the corridor. . . . Each fixture holds two differently colored bulbs [in combinations of pink, green, yellow, and blue] shining in opposite directions."

The colored bulbs create the rooms' only atmosphere. While you can walk to the end of each corridor, down to the bottom of the U, and peer through the slats between the lights, the installations are far more successful from the edges. Turn-

ing your back on the searing Texas sun, inadequately blocked by the covers on the windows, you face floating, inviting areas of color, glowing softly at the end of the hall. If the lights were golden, it would look like a pirate's chest or a leprechaun's pot of gold, waiting for you at the end of a short journey.

The most successful of the pairings were those made with the strongest colors. Pink and blue don't travel well, and the effect is almost too soft to be recognizable, or it has to work too hard against the ambient light coming in (I felt the same way at the Flavin installation at Dia:Beacon; the natural light is so strong that it renders Flavin's white lights weak and ineffectual). While time is not an element here in the same way it is with Judd's boxes, Flavin's tunnels involve a comparable level of interaction and choice. You can hang back and observe the light from the parallelograms. You can enter the shorter hallways and walk right up to the symmetrically installed bulbs, which are alive in their own way. Or you can hover at the threshold between the light and its source, standing at the lip of explanation, bathed in light without tracing it back to its origin (knowing, however, that the origin is just around the corner).

Another stop on our afternoon tour was the installation devoted to the Icelandic artist Ingólfur Arnarsson. I was mesmerized by the two small paintings and thirty-six even smaller graphite drawings on paper mounted directly on the wall. Entering the room, we saw what looked like a monotonous row of light grey rectangles, all installed at the same height, on the wall or on a support, we couldn't tell. At first it seemed a minimalist nightmare, payback time for the pleasure we had taken with Judd's boxes and Flavin's lights. What do you do with thirty-six gray rectangles? But as had happened so often on this trip, close inspection proved the seemingly undifferentiated rectangles to be remarkably varied, each created using different patterns of cross-hatching, some loose, some dense. In an essay on the Chinati Web site, foundation direc-

tor Marianne Stockbrand describes how the "pictorial surface breathes, it is transparent like a veil."

It was another example of art teaching a lesson about the value of close perception. Arnarsson's gray rectangles could be easily overlooked, and in a museum they quite possibly would be. To be appreciated they needed to be viewed from literally inches away; at that distance, they expand like the surface of the ocean. Each work displayed an extraordinary variety, with subtle shifts in the pace and texture of the thousands of lines coming together and then breaking apart. Critics and historians sometimes view surfaces, whether impressionist oils or Renaissance temperas, with microscopic exactitude. But I believe most people need to be taught to pay such close attention to surfaces whose richness might not, at least initially, be apparent. Works like Arnarsson's reward such attentive viewing, just as the *Lightning Field* rewards patience.

Judd's boxes, Flavin's lights, Arnarsson's tiny immensity—these works were a balm to my soul and the best of what I had hoped for when contemplating this excursion to Marfa. I had seen very few works by Judd and Flavin in such a context—elsewhere they were usually folded into galleries alongside work by other artists—and I was surprised by the difference context and repetition made. The Judds I have seen since pale in comparison. A few cubes on the floor are vulnerable to Michael Fried's critique of objects that are merely "in the way," but the hundred boxes become their own environment, and Fried's language simply does not apply.

Had I seen only these three installations while in Marfa, I would have left feeling restored, like I had been on a weekend trip to the beach. The creativity and expressiveness conveyed with such economical means, and within such strict, orderly parameters, exhilarated me. It spoke to the liberation possible through compulsion, which to me represents the height of invention. But within this regularity, disturbances erupted.

The first eruption was *School No. 6*, an installation created by Ilya Kabakov in 1993 specifically for Chinati. We had seen Kabakov's work in the morning, immediately after the aluminum boxes. Designed to look like an abandoned Soviet schoolhouse, *School No. 6* was a series of rooms that appeared to have been hit by a tornado and left to ruin. Broken furniture, strewn papers and photographs, bird droppings on the floor. The walls were water-stained, the windows open to the elements, the paint peeling. Overgrown grass filled a courtyard. The immediate sense was of devastation and loss, of recent tragedy.

On the Chinati Web site, Kabakov offers a brief history of the concept of the installation, focusing on the abandonment of a village school as "the working village ... gradually started to decay and die." Soon there was no reason to maintain the school and its gym classes, music lessons, and buffet cafeteria. "Today there is emptiness and oblivion there, where just yesterday there was life and voices resounded."

When I had talked to people about going to Marfa, all of them described this Kabakov installation as very powerful: "Oh yeah, the boxes. . . . But then there's this abandoned schoolroom thing that is just amazing!" To me it seemed incongruous compared to what I had seen in the past two weeks and even the previous hour. All of a sudden I was torn from the antiseptic solemnity of the hundred boxes and confronted with *stuff*, lots of stuff, a choking amount of stuff: tiny tags of paper to read, photographs to look at, marks on the blackboard, sheet music to decipher, hundreds of objects to consider. The order of experience was too discordant for me, and I wound up hightailing it out of that building to sit outside and wait for the others. It's not that I thought the installation lacked power, but it required a mode of looking and processing antithetical to that of the rest of the trip. A wave of messy emotions and events were suddenly made literal to me—loss,

abandonment, destruction, despair, hopelessness—without my having to do any work. I felt cheated, like it was all too easy.

When everyone was finished with the Kabakov, we piled into our cars and headed back to downtown Marfa for the galleries devoted to John Chamberlain, the second eruption. Chamberlain has never been at the top of my list, and I simply can't understand why Judd or Dia offers him exhibition space at every available turn. He has huge spaces both in Marfa and at Dia:Beacon. One of the first things I read, when we arrived at the former wool warehouse that contains his works, was his statement: "In what I do, constant hard work is not necessary. My drive is based on laziness. . . . I don't mind admitting that I'm lazy because laziness is for me an attribute." Like Kabakov's installation, Chamberlain's words struck a discordant note—though I am as much a fan of laziness as the next person. Smithson, Heizer, Turrell, and Judd are and were consumed by a compulsive desire to work and to achieve their own version of perfection. Smithson's *Spiral Jetty*, for example, is actually only a third of the total work, the other parts being an essay and a film. Heizer has destroyed his health working ceaselessly on *City*. Turrell has similarly spent decades funding and building *Roden Crater*. And Judd, according to Kimmelman, organized his life and work with "everything obsessively given its own space, definition, and attention, in sometimes belligerent disregard for basic comfort and with a puritanical resistance to extraneous form" (Kimmelman, *Masterpiece*, 192).

I confessed to our cute guide that I didn't understand Chamberlain's work—it seemed sloppy and disorderly. "I just don't *get* him," I said. "What's here? What do you see in this? What am I supposed to be getting?"

"We're not supposed to offer any interpretations," he said. "We're just supposed to let you look."

"You mean I can't even ask you what this means or what's supposed to be behind this?"

"You can ask, but I'm not really supposed to answer. You're supposed to draw your own conclusions."

"I'm sorry, but that doesn't seem like being a very good guide to me."

He dropped his voice into a conspiratorial whisper. "To me, these all look like crumpled abstract expressionist paintings. Try to stop seeing them as things. Try to see them as shapes instead."

That didn't help. Marfa was not the place to engender in me a devotion to John Chamberlain. Once again, I went outside to wait while the others looked around. Days later, when I got home and downloaded my pictures, I realized that the only installation I had no record of was Chamberlain's.

Our last stop of the day, after returning to Chinati for work by Carl Andre and others, was the related tour of Judd's home, which is administered separately, with a separate tour guide and a separate admission fee. We left Fort Russell and returned downtown in a two-minute drive. Yellow and Mrs. Yellow accompanied us, but the rest of our small group broke off to do other things. "I'm tired of edges," said one man as we parted ways.

We were met at La Mansana de Chinati by an older gentleman, a longtime Marfa resident and a friend of Judd's. He laid out the rules: no pictures, no wandering off from the tour, no taking of mementos (I took a bamboo leaf from Judd's garden). We were standing in a gravel courtyard in the middle of a complex of buildings. A thick adobe wall surrounded the compound. It was one of the points of hostility, according to Langewiesche, between Judd and the Marfans. "They don't care about his aesthetics," Langewiesche wrote. "They see only the outside of the walls, and they feel excluded and insulted." Judd didn't care. "We don't have a real community here," Judd reportedly said. "We did have one and it wasn't nice. Maybe now we'll have nothing" (in Langewiesche, 180).

One of Judd's jeeps, the interior tricked out in aluminum, was parked near the entrance to the compound next to the locked gates and a shallow rectangular pool over which slight trees moved with the gentle wind. The pool wasn't immaculately clean; like the barracks at Fort Russell, it bore a studied sense of decay, though photographs of the pool invariably depict it as a field of brimming turquoise.

"The Block" consists of three huge buildings and a number of sheds and outbuildings. The two largest buildings formerly belonged to the army—one was the office of the quartermaster corps—and house studios, a large library, Judd's personal living quarters, and galleries. They are separated by a gravel area flanked on three sides by an eight-foot-tall retaining wall. It was as if Judd wanted to leave room for a volleyball court. At the edge of this gravel field is the building where his children lived, a two-story house that we weren't allowed into.

The tour began with the west building, which held his library, of particular interest to me. The first room was a huge, well-lit gallery space that holds a permanent installation of some of Judd's work, including freestanding red and black sculptures, a planar floor work, and a stacked cubic unit that looks like a kindergarten cubby system for a school with thousands of students. There was a dining room table and chairs and stereo speakers propped on the floor. The docent explained that Judd liked to use each of his rooms for multiple purposes; even the galleries at the Mansana were not "pure" galleries in that Judd often used them as sitting rooms, dining rooms, and even bedrooms. The light was filtered first through trees and then through his four-square windows, falling with regularity and symmetry on the sculptures and the floor, replicating the order of the work with its own right-angle shadows.

The library occupied the middle and largest section of the west building. It has yet to be cataloged or made formally

available to scholars, the result of bad blood between the Chinati and Judd foundations. The girders and structural apparatus of the ceiling are all visible, and the vast space of the building is divided by brick walls that reach up to, but not beyond, the apparatus, so one has the sense of a continuous open space at the very top of the building. Sound carries across its length.

Judd's books sit on identical shelves in several long rows. The shelves are deep, and the books are set far back, so you have to reach further into the units to retrieve the books than you would with a standard bookshelf. This is a small adjustment Judd made to the form of the bookshelf, but it seemed significant to me. His home and studios were variations on common domestic forms, tweaked just slightly (heavier in the legs, deeper in the shelves). He had thousands of books, in many languages, loosely grouped into categories and placed both vertically and horizontally on the shelves. There were philosophical standards (Kant), historical classics (*Democracy in America*), and thorough runs of art and design magazines housed in a separate section. Heartbreakingly, there were a few books on surviving cancer, though from what I understand, Judd was diagnosed with non-Hodgkins lymphoma in Germany and died just two months later in New York City, without returning to Marfa.

The library includes a worktable as long as the room is wide, stacked neatly (presumably as Judd left it) with books and papers, rocks and other objects, notebooks, and a Beuysian hat. Judd-designed four-square chairs are scattered around the table and pulled up facing the shelves. Off one end of the library is a door that leads into what adventure seekers might take to be a secret chamber. ·

There the aesthetics of right angles break down. An overstuffed leather chair sits squarely in front of a window that looks out onto a tiny garden filled with bamboo. There is a

small table and (gasp) a rug on the floor. This was Judd's personal reading room, our docent explained. He liked to sit reading in the leather chair, occasionally looking out the window at his lush, not spare, garden. It didn't fit with the rest of the work spaces we had seen and contained the first piece of "traditional" furniture we had encountered so far. It looked more Sherlock Holmes than Donald Judd.

The west building, across the "volleyball court," mirrored the east building—a long shed broken into three separate sections—though instead of being divided by brick walls it was divided by white drywall, rough at the top edges, which again did not reach the high ceiling. The first room we entered was another gallery space, populated by metal works and by stacked rectangular units that framed the doors between rooms. Here too were several freestanding variations on the aluminum boxes. The windows were high and carefully measured, again casting shadows that underscored the regularity of the stacked rectangles. In the corner of the room was a low bed, a futon or mattress resting on an only slightly larger pallet. Judd didn't always sleep in his bedroom, the docent told us, as if the artist were an animal whose behaviors needed to be explained. Sometimes he would just sleep where he happened to be; that's why so many of the rooms contained beds. They were literally crash pads, yet still beautifully designed and harmoniously integrated into their surroundings.

On the other side of the framed doors were Judd's personal living quarters. I was disappointed that his kitchen looked pretty much like a kitchen; domestic invention can only go so far against culinary convention. The guide told us that Judd hired a woman to come in and cook for him, that left to his own devices the artist "would probably starve." On the other side of the kitchen was another large gallery with more work in it. Sharing the middle third of the building with the kitchen was Judd's actual bedroom.

I was dying to see what the inner sanctum of the Nietzs-chean Judd looked like. Here would be the sacred altar, the undistillable essence of all that was Judd. The docent opened the door and we entered the room. It was the final eruption. My eyes settled first on a Chippendale-style writing table, complete with whirls and curved, spindly legs. A brightly patterned blanket was on the pallet bed in the middle of the room. The centerpiece of the bedroom was a massive stone fireplace, the mantel piled with turquoise and silver objects, jewelry—and crap. In the midst of this ordered domestic concerto, the turquoise and silver, the writing table, the patterned blanket, the tchotchkes struck a horribly wrong chord. How could this be? I turned to Todd with my wordless question. "I don't know," he answered.

I had always imagined Judd drifting off to sleep in something like an operating room, all shiny and clean and sterilized and ordered. But this mountain of turquoise, this precious, spindly little desk—these were his treasures? I wanted to believe that the aesthetic he projected and promoted came from his very core, just as Albert and Gladys's idiosyncrasies had permeated every inch of Hole n" the Rock. If it were possible to live so clinically, he would be the one to carry it off. But he hadn't. Supreme control of shape and space determined virtually every other area of his existence, but where it really mattered—where it could be proved to be an essence, a foundation—it was absent. Does that mean that his moral order, his *strict measure*, were ultimately unsustainable? Could they only be defined against the Chippendale, the turquoise and the silver?

Judd's bedroom embodied for me the tensions inherent in everything I had seen on this trip. I had expected monoliths but instead found conflict at every turn. Were earthworks objects or environments? Did they function as markers of space or markers of time? Did they have that self-sustaining quality

that Michael Fried prescribed, or did they depend entirely on the presence of a viewer for their existence? Was absolute control over context ever possible, or would nature or human nostalgia always intervene?

These questions remain unanswerable to me, complicated now irreversibly by my pilgrimage. Despite the problems inherent in Clement Greenberg's theory of modernism—that modernist art moved in a constant progression of self-criticism, striving in every generation from impressionism to abstract expressionism to further define the limits of its own medium—his ideas, and Fried's, had long been attractive to me. I felt secure in their closed systems. But I had not felt fully alive to the knot of artistic experience that existed outside the lineage they constructed. I had believed that art teaches you about art, about its own formal constructions, solutions. It is specific to its medium and operates within that medium alone. In *Finnegans Wake* James Joyce expanded what language could be and do by stretching language itself; Jackson Pollock's drip paintings pushed paint itself in a new direction. This self-criticism is the essence of modernism.

While I didn't expect earthworks to participate in the modernist conversation—they came too late, they weren't about a specific medium—I didn't think they would blow the belief system open as they did. Each work I had seen on this trip, as well as Judd's bedroom, forced me to reconsider the value of "art for art's sake." The experience of time and duration brings a work out from its sealed container into the world of traffic lights and cloudy days and pencil sharpeners. It becomes contingent on how, when, and where it is viewed. Because it enters this world, it teaches you something not about itself but about this world. The *Lightning Field* awakens in my memory a pure sense of being highly attuned to my environment, to the light and air and space around me. It drove me to attentiveness and continues to give me a stage and the

mechanisms to fully experience my surroundings. Clearly, its message was not about art; it was about how we relate to the objects and atmospheric qualities around us. The same is true of Judd's boxes.

I suppose that this idea veers uncomfortably close to the belief that great art is about self-improvement, that we come to art to be taught something about ourselves. But I suspect far more people would come to museums if the modernist view didn't still hold sway. People visit the Museum of Modern Art to learn about modern art, not about themselves. But would more people come if they thought some sense of personal transformation were at stake? I set out on my trip wanting to learn about art, but I was realizing that the most significant thing I learned out in the West was *via* art, not about it. Does that make *Lightning Field* more or less valuable than analytical cubism?

The next morning, after buying bumper stickers that read "wwDJD?" (What Would Donald Judd Do?) at the Marfa Book Company and before heading to Midland / Odessa to drop Todd at the airport and start my drive back to Chicago, we headed back to the foundation. We wanted to check out the fifteen concrete bunkers that Judd had built in the field adjacent to the artillery sheds. They were the first works to be installed at the site. As with the boxes, each has the same dimensions (2.5 by 2.5 by 5 meters) but each is configured differently. It was hard to get a good view of the row from the path leading from the "lobby" to the artillery sheds, so we decided to go into the field and get closer to them.

Todd said he was "maxed out on Judd." I asked if that were even possible. He replied, "Well, it *is* a lot of Judd." I complained that all the bushes and grasses were scratching my legs and ankles and I felt like I was getting bit by bugs. We got to the bunkers, which seemed like bunkers and nothing more. Yes, the shadows fell differently in each, but you couldn't get

a sense of either the whole or its parts; you were either inside missing something or outside missing something. Plus it was hot. I wondered aloud if the bunkers were like the *Lightning Field* test site, through which Judd discovered something about proportion and placement that would serve him in better planning his aluminum boxes. Todd said he didn't care. It was time to go. We climbed into the Jetta and started driving home.

Doing the Pilgrimage

THE ROUTE

I chose a loosely counterclockwise circle through the states of Utah, Nevada, Arizona, New Mexico, and Texas, visiting the various sites in the order in which they appear in this book. All of the earthworks are within a few hours' drive of the major interstates.

Spiral Jetty

To reach *Spiral Jetty*, take I-15 north from Salt Lake City to Corinne (exit 368), just west of Brigham City, Utah. Follow Route 83 through Corinne and continue west, following the signs to the Golden Spike National Historic Site. The Park Service had, at the time of my trip, installed signs pointing the way to the *Spiral Jetty*, which makes the trip considerably easier. Don't worry if you seem to travel a great distance without seeing any directions; the signs are sparse but well placed, and you should have no trouble finding your way. *Spiral Jetty* will not be visible from the road, but if you make it to the rusted-out amphibious vehicle and the old Dodge truck, you are practically on top of Smithson's work.

Sun Tunnels

Clearly I am the wrong person to offer directions to the *Sun Tunnels*. I can only describe with confidence taking I-80 west

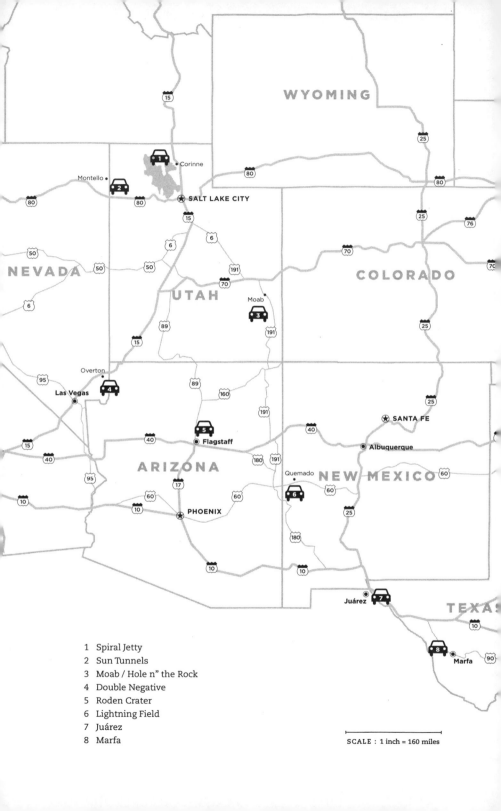

1 Spiral Jetty
2 Sun Tunnels
3 Moab / Hole n" the Rock
4 Double Negative
5 Roden Crater
6 Lightning Field
7 Juárez
8 Marfa

SCALE : 1 inch = 160 miles

from Salt Lake City past Wendover, Nevada, then NV 233 northeast, back over the state line, where it becomes Utah 30. You'll pass through Montello, so be sure and stop at the Saddle Sore. A recent visitor to the *Sun Tunnels*, blogger Tyler Green of *Modern Art Notes*, encountered the same difficulties I did trying to follow two conflicting sets of directions. More tolerant of ambiguity, he stuck it out and succeeded, with the help of GPS coordinates from the Center for Land Use Interpretation site, so follow the route he describes at http://www.artsjournal.com/man/archives20060901.shtml#107395.

Double Negative

Overton, Nevada, the site of *Double Negative*, is north and east of Las Vegas. From I-15, take exit 93 (NV 169 south), and follow 169 southeast into Overton (about eleven miles). The Overton airport has the most complete directions to the work; to get there turn left on Cooper Street or just follow the signs. Since my trip another good set of directions has been published online, at http://doublenegative.tarasen.net/directions.html, courtesy of Nick Tarasen. A summary of his instructions, starting from the airport, follows:

> Turn right (northeast) on Mormon Mesa Road. Follow this partially paved road to the top of the mesa and across a first cattle guard. Continue east for 2.7 miles. If you reach the east edge of the mesa and start to descend, you have gone too far. At the east edge of the mesa is a second cattle guard. Just before the cattle guard is a less-traveled road that follows the rim of the mesa; turn left (north) and follow this rim road for 1.3 miles. Park your vehicle, and walk east toward the rim of the mesa. You should be within fifty yards of *Double Negative*.

And of course, don't fall in.

Lightning Field

You'll need a reservation at *Lightning Field*, and a trip to the site should not even be attempted without one. Even if I knew how to get there, the route is filled with locked gates that make unaccompanied entry impossible. The *Lightning Field* is open from May 1 to October 31, every day. The Dia Foundation begins taking reservations on March 1 for that year's season. You will need to snail-mail in a reservation form with a check or money order to the office in Quemado. The fee per night has gone up since my trip: it is now $150 per person in May, June, September, and October and $250 per person in July and August. There is a student rate of $100 per person, which is good for all months.

Once you have your reservation, you will need to be in Quemado by 2:30 PM on the appointed date. Dia recommends taking I-40 west from Albuquerque to Route 117 south (exit 89) and then simply following the signs to Quemado. Todd and I wanted to see some pueblos, so we instead took I-25 south to Route 60 west, which will take you straight into Quemado. Either way, leave yourself a generous amount of time to get there. Better to be twiddling your thumbs in Quemado at 2:00 PM than to be stuck behind an RV on Route 60 at 2:25 PM. Plan on at least three hours from Albuquerque.

All the information you need is at http://www.lightning field.org.

Marfa

I-10 is the major east-west route through Texas. If you're coming from the west, take it east to the Van Horn exit (140A), then follow Route 90 south and east straight into Marfa. If you are coming from the east, take I-10 to Route 67 (exit 248), then Route 67/90 west into Marfa. The viewing grounds for

the mysterious Marfa Lights—the strange glow over the mountains at night that may or may not be apocryphal—is east of Marfa on 67 / 90.

There is no need to make reservations for the Chinati Foundation tour or the tour of Judd's home.

WHAT YOU'LL NEED

Cheap—often chain-motel—lodging is plentiful in the major towns and cities along all of these routes, so there is no need to bring camping equipment unless you want to stay overnight at one of the sites, save a few bucks, or spend the night in the *Lightning Field* itself. (Though if you want to visit Marfa during their annual open house, the first weekend of October, you may find yourself shut out of the hotels.) Camping at *Spiral Jetty*, *Sun Tunnels*, and *Double Negative* is not specifically encouraged or discouraged. Land rights and access at the sites are vague at best. Heather said she had camped overnight at *Spiral Jetty* but no one I encountered had done so at any of the other sites. The *Jetty* would be the most promising place to do so, if you're so inclined.

Many of these works are very remote, and help is a long way off if you encounter car trouble or injury. For this reason, I would not recommend taking the trip in a car that rides low to the ground. The roads to *Spiral Jetty* and the *Sun Tunnels* especially are deeply rutted, with medians filled with large, sharp rocks that can seriously damage the undercarriage of a car or puncture a tire. Be sure you have a good spare tire and know how to use a jack. Extra water and a first aid kit wouldn't hurt, either.

For navigation, a car or SUV equipped with GPS would be ideal. Short of that, bring a compass. The area around the *Sun Tunnels* and Mormon Mesa offer a lot of monotonous terrain in which landmarks can be hard to locate.

Bring your cell phone, of course, but be forewarned that reception will be spotty, and not just in the remote areas. Even the interstates are full of dead zones, so don't expect continuous communication with anyone who isn't in the car.

Temperatures can vary widely, particularly in the high desert. A daytime high of eighty degrees can sink to the frost threshold after the sun goes down. Bring clothing you can easily take on and off; layering, as any winter runner will tell you, is key. Also make sure that your wardrobe includes wicking fabrics. Hours on Mormon Mesa or next to *Spiral Jetty* can produce a lot of sweat, which will make cotton uncomfortable in those long walks back to the car. Bring comfortable shoes, and expect to throw them away once you get home. Dirt, dust, and sand will seep into every instep and eyelet.

And of course don't forget sunscreen and a hat. And aspirin, for that Saddle Sore hangover.

Readings and References

A great general essay on most of the sites visited in *Spiral Jetta* is Michael Kimmelman's chapter "The Art of the Pilgrimage," in *The Accidental Masterpiece*. No trip to *Spiral Jetty* should be attempted without poring over *Robert Smithson: Spiral Jetty*, edited by Lynne Cooke and Karen Kelly. Those who want to go deeper into Smithson's world would be well served by *Robert Smithson: The Collected Writings*, edited by Jack Flam. Kimmelman's articles on Michael Heizer remain the most illuminating and accessible writing on the artist that I have encountered. For *Roden Crater*, Calvin Tomkins's *New Yorker* essay on James Turrell, "Flying into the Light," is the best stand-in I could find for an actual visit. The most comprehensive guide to the *Lightning Field* is Walter De Maria's binder in the cabin itself, so you'll have to trust me on this and read it when you get there. Finally, a good introduction to the work and life of Donald Judd is *Donald Judd*, by David Batchelor, John Jervis, David Raskin, Nicolas Serota, and Richard Shiff. Judd's complete writings, recently reprinted by the Nova Scotia College of Art and Design, is harder to find but worth the effort.

The following list includes all sources cited in the text, as well as further related readings.

Batchelor, David, John Jervis, David Raskin, Nicolas Serota, and Richard Shiff. *Donald Judd*. New York: Distributed Art Publishers, 2004.

Battcock, Gregory, ed. *Minimal Art: A Critical Anthology*. Berkeley: University of California Press, 1995.

Beardsley, John. *Earthworks and Beyond: Contemporary Art in the Landscape*. New York: Abbeville, 1998.

Boettger, Suzaan. *Earthworks: Art and the Landscape of the Sixties*. Berkeley: University of California Press, 2004.

Bowden, Charles. *Down by the River: Drugs, Money, Murder, and Family*. New York: Simon and Schuster, 2004.

———. *Juárez: The Laboratory of Our Future*. New York: Aperture, 1998.

Breslin, James E. B. *Mark Rothko: A Biography*. Chicago: University of Chicago Press, 1993.

Brown, Julia, ed. *Michael Heizer: Sculpture in Reverse*. Los Angeles: Museum of Contemporary Art, 1984.

Celant, Germano. *Michael Heizer*. Milan: Fondazione Prada, 1991.

Cooke, Lynne, and Karen Kelly, eds. *Robert Smithson: Spiral Jetty*. New York: Dia Art Foundation; Berkeley: University of California Press, 2005.

Dean, Cornelia. "Drawn to the Lightning." *New York Times*, September 21, 2003.

Eaton, Robert. *The Lightning Field: Travels in and Around New Mexico*. Boulder: Johnson Books, 1995.

Elkins, James. *Pictures and Tears: A History of People Who Have Cried in Front of Paintings*. New York: Routledge, 2001.

Fried, Michael. *Art and Objecthood: Essays and Reviews*. Chicago: University of Chicago Press, 1998.

Goldstein, Ann, ed. *A Minimal Future? Art as Object 1958–1968*. Cambridge, MA: MIT Press, 2004.

Hall, Michael. "The Buzz about Marfa Is Just *Crazy*." *Texas Monthly*, September 2004, 136–43.

Joyce, James. *Ulysses*. New York: Vintage, 1986.

Judd, Donald. *Complete Writings 1959–1975: Gallery Reviews, Book Reviews, Articles, Letters to the Editor, Reports, Statements,*

Complaints. Halifax: Press of the Nova Scotia College of Art and Design, 2005.

Kastner, Jeffrey, ed. *Land and Environmental Art*. 2nd edition. London: Phaidon, 2005.

Kimmelman, Michael. *The Accidental Masterpiece: On the Art of Life and Vice Versa*. New York: Penguin, 2005.

———. "An Artist at the End of the World." *New York Times Magazine*, February 6, 2005, 32ff.

———. "The Greatest Generation." *New York Times Magazine*, April 6, 2003, 30ff.

———. "Michael Heizer: A Sculptor's Colossus in the Desert." *New York Times*, December 12, 1999.

Langewiesche, William. *Cutting for Sign: One Man's Journey along the U.S.–Mexican Border*. New York: Vintage, 1995.

Lee, Pamela. *Chronophobia: On Time in the Art of the 1960s*. Cambridge, MA: MIT Press, 2006.

———. "The Cowboy in the Library." *Bookforum*, December/January 2005, 6–12.

Meyer, James. *Minimalism*. London: Phaidon, 2005.

McPhee, John. *Annals of the Former World*. New York: Farrar, Straus and Giroux, 1998.

Newman, Barnett. "Prologue for a New Aesthetic." In *Barnett Newman: Selected Writings and Interviews*. Ed. John O'Neill. Berkeley: University of California Press, 1992.

Reynolds, Ann. *Robert Smithson: Learning from New Jersey and Elsewhere*. Cambridge, MA: MIT Press, 2004.

Roberts, Jennifer. "The Artist and the Salt of the Earth." Excerpt in *Chronicle of Higher Education*, February 4, 2005, B19. Full essay in Tsai, below.

———. *Mirror-Travels: Robert Smithson and History*. New Haven: Yale University Press, 2004.

Sanford, Melissa. "The Salt of the Earth Sculpture." *New York Times*, January 13, 2004.

Sayre, Henry. *The Object of Performance: The American Avant-Garde since 1970*. Chicago: University of Chicago Press, 1992.

Schwarz, Benjamin and Christina. "Around the Big Bend." *Atlantic Monthly*, April 2000, 42–47.

Smithson, Robert. *Robert Smithson: The Collected Writings*. Ed. Jack Flam. Berkeley: University of California Press, 1996.

Tomkins, Calvin. "Flying into the Light." *New Yorker*, January 13, 2003, 62–71.

———. "The Mission." *New Yorker*, May 19, 2003, 46–53.

Tsai, Eugenie, ed. *Robert Smithson*. Berkeley: University of California Press, 2004.

Urrea, Luis Alberto. *The Devil's Highway: A True Story*. New York: Back Bay Books, 2005.